Aesthetics and the Sociology of Art

Aesthetics and the Sociology of Art

Second Edition

JANET WOLFF

Ann Arbor Paperbacks
THE UNIVERSITY OF MICHIGAN PRESS

First edition as an Ann Arbor Paperback 1993
Copyright © Janet Wolff, 1983, 1993
All rights reserved
Published in the United States of America by
The University of Michigan Press
Manufactured in the United States of America

1996 1995 1994 1993 4 3 2 1

A CIP catalogue record for this book is available from the British Library.

Library of Congress Cataloging-in-Publication Data

Wolff, Janet.
 Aesthetics and the sociology of art / Janet Wolff. — 2nd ed.
 p. cm. — (Ann Arbor paperbacks)
 Includes bibliographical references and index.
 ISBN 0-472-09499-8 (alk. paper). — ISBN 0-472-06499-1 (pbk. :
alk. paper).
 1. Aesthetics. 2. Art and society. I. Title.
BH39.W63 1993
700'.1—dc20 92-33285
 CIP

for
Rebecca and Maurice Noar
and
Bertha and Josef Wolff

Acknowledgements

I would like to thank Gi Baldamus, Zygmunt Bauman, Tony Bryant, Aidan Foster-Carter, Griselda Pollock, John Seed and Bob Towler for reading and commenting on the first typescript of this book. I would also like to thank Tom Bottomore and Mike Mulkay for their encouragement and helpful comments.

Contents

Introduction to the Second Edition:
Aesthetics in Postmodern Times xi

1 The Sociological Critique of Aesthetics 11

2 Sociology versus Aesthetics 27

3 Political and Aesthetic Value 48

4 The Nature of the Aesthetic 68

5 The Specificity of Art 85

6 Towards a Sociological Aesthetics 105

Bibliography 117

Index 127

Introduction to the Second Edition: Aesthetics in Postmodern Times

A lot has changed in the ten years since I wrote this book. In the arts, in the academy, and in the broader social arena, questions of aesthetics have had a new prominence in Euro-American culture. Most surprisingly, an area of rather esoteric interest has become one of the major public battlefields of political debate. In addition, scholars in the humanities have manifested a much greater interest in a social-critical approach to the arts than hitherto; conversely, those in critical cultural studies are beginning to argue for a return to the aesthetic. And yet, as I will argue in the final chapter of this new edition, it turns out that these are the very reasons for restating the case I make in the book. For although a lot has changed, the structures and arguments of opposition between the social and the aesthetic are by no means clarified or reconciled.

It is certainly no longer possible to mount a general critique of the practices and ideologies of the humanities. In the past ten or fifteen years, the disciplines of literary criticism, art history, and even, more recently, musicology have been transformed (or at least invaded) by critical approaches informed by social-historical method and analysis. Much of this has to do with the political critiques of feminism and postcolonial criticism. (In the United States, as opposed to Britain, the critique from the basis of class analysis has been secondary to these interests.) Some of it has been more the product of theory (especially so-called poststructuralist theory) than the outcome of political commitment. As I shall say in the final chapter of this book, I have serious reservations about the claims of much of this work to be sociological analysis. But the great proliferation and enormous visibility of studies in the new literary history, feminist criticism, the new art history, and other critical disciplines has been re-

markable. At the very least, one can say that the sociological critique has been taken seriously. (This is not, of course, to claim that humanities scholars have been influenced by sociologists or their work. One thing that hasn't changed much is that the disciplines remain self-contained and distinct, and in particular the divide between the social sciences and the humanities has barely begun to be crossed.)

Also worth noting has been the publication of many texts that have taken up directly the issue of the social production of the aesthetic. Some of these have been historical: for example, Lawrence Levine's and Paul DiMaggio's studies of the historical emergence of aesthetic hierarchies (highbrow/lowbrow) in the nineteenth century, and Peter Burger's exploration of the emergence of the institution of art and the aesthetic as a distinct realm (Levine, 1988; DiMaggio, 1982; Burger, 1984). Some have been philosophical and theoretical, like Jacques Derrida's redefinition of the aesthetic (Derrida, 1987) and Terry Eagleton's detailed history of the social basis of aesthetic theories (Eagleton, 1990). Feminist historians have demonstrated the gender basis of aesthetic hierarchies (for example, Parker, 1984; Felski, 1989), and theorists of postcolonialism have explored the ways in which museums and other cultural institutions collaborate in the construction of ethnocentric evaluations of art and culture (Clifford, 1988; Karp and Lavine, 1991). And, importantly, a decade of discussion of 'postmodern' culture and philosophy, with its associated relativizing of *all* value, has produced new challenges to a traditional aesthetic, as well as different problems for a sociology of culture (see Foster, 1983; Benjamin and Osborne, 1991). All of these will be discussed in the last chapter.

Rethinking these issues in the early 1990s, it is impossible to ignore the ways in which ostensibly aesthetic issues are being played out in the political arena, particularly in the United States (see Bolton, 1992). The destructive and bitter debates about 'political correctness' (PC), while primarily focused on the curriculum in institutions of higher education (and the supposed attack on Western values) have also been centrally about culture. The defenders of traditional values,

in the face of their construction of a PC threat to abolish the study of Western culture—for the most part a construction in fantasy but nonetheless one apparently effective in mobilizing many people—have paid a good deal of attention to the defence of Great Art and the canons of literature, art, and music which are assumed to be at risk (see Aufderheide, 1992; Berman, 1992). This high visibility of questions of the aesthetic in the public sphere was certainly inconceivable ten years ago.

And yet this is also the evidence that, however much things have changed in a decade, fundamentally they remain the same. For what we have been seeing is the current strategy of an old project: the traditional defence of established values (among which cultural and aesthetic values have always been primary) and the resistance to any critical modes of thinking. These are issues I raise, though in a different form, in the book. To that extent, I still believe that it is necessary to make the case for a sociological aesthetic. The statements of Hilton Kramer, Allan Bloom, E. D. Hirsch, Dinesh D'Souza, and other conservative writers on culture are merely the latest version of the agitated responses in the 1970s to the work of Eagleton, Raymond Williams, T. J. Clark and others.

There is another reason why I think the relations between the aesthetic, the political, and the social continue to need to be examined, and this has to do with my concern with the adoption (and adaptation) of critical approaches in the humanities, particularly in North America. In Chapter 6 (the only section of the book rewritten for the second edition) I will suggest that a good deal of this work only pays lip service to the sociological. In addition, in taking over terms like 'cultural studies' (much in vogue these days in literature departments and in the Modern Language Association in the United States), many writers have clearly transformed this project from its original form (as developed, for example, at the Centre for Contemporary Cultural Studies at the University of Birmingham through the 1970s and 1980s). Of course nobody has a patent on the label 'cultural studies', and the fact that nowadays it often seems to describe new and inge-

nious textual readings does not mean that in some ways this is 'mistaken'. But this new project of cultural studies is not necessarily one which participates in the social-historical analysis and critique of the aesthetic (see Nelson, 1991).

This book deals with what I have called 'the sociological challenge to aesthetics'. It reviews the many ways in which sociological approaches (not always or necessarily within the professional discipline of sociology) raise uncomfortable and important questions for traditional aesthetics. I discuss the variety of responses to this challenge, and raise the question of the relationship of questions of political value to questions of aesthetic value. But the book is as much a *defence* of aesthetics as a critique of *traditional* aesthetics. I very much want to resist any hint of 'sociological imperialism', in which the aesthetic is entirely reduced to social and political issues (see Wolff, 1992). I therefore conclude the study with a discussion of the specificity of the aesthetic, maintaining that the discourses and institutions of the aesthetic sphere retain an autonomy from the social. As evidence of my commitment to this view, for the cover of the new edition of this book I have selected a work by Emil Nolde, whose politically incorrect politics I allude to in Chapter 2.

1

The Sociological Critique of Aesthetics

This book is concerned with the question of aesthetic value. It considers in particular the implications for aesthetics of developments in the sociology of art, a discipline which, on the face of it, might appear to subsume or abolish altogether the philosophy of art. I should make it plain from the outset that in referring to 'art' and 'the arts' I mean to include paintings, novels, music, film and all cultural products. In this chapter I shall discuss some of these developments and present the sociological critique of some aspects of traditional aesthetic theories – that is, theories about the nature of art. I shall argue that the sociology of art and the social history of art convincingly show the historical, ideological and contingent nature of a good deal of 'aesthetics' and of many, if not all, 'aesthetic judgements'. They also render problematic the unquestioned categories of criticism and aesthetics, forcing us to recognise the impossibility of counter-posing 'great art' to popular culture or mass culture in any simplistic manner. (The question of the essentially *social* nature of any aesthetic experience or aesthetic judgement will be taken up again in more detail in Chapter 4.) I shall then suggest that the sociology of art has in some ways exceeded its own brief, in so far as it fails to account for the 'aesthetic'. Indeed, the central theme of this book is the irreducibility of 'aesthetic value' to social, political, or ideological co-ordinates. This has become an increasingly worrying problem among sociologists of art and Marxist aestheticians, who, while rightly refusing to reinstate any essentialist notion of 'the aesthetic', have begun to see the need to

12 *Aesthetics and the Sociology of Art*

accord recognition to the specificity of art. (Some of their deliberations and tentative suggestions are considered later in this book, particularly in Chapters 3 and 5.) This chapter concludes by outlining the arguments and organisation of the rest of the book.

Traditional aesthetics originated in the eighteenth century, particularly in the work of German philosophers and writers (Baumgarten, Kant, Schiller). Since that time it has been construed and practised, not as an aspect of art history or of art criticism, but as a branch of philosophy. It has been variously conceived as ontology, epistemology, or analytic philosophy, though these distinctions need not concern us at the moment. It has centrally been concerned with the nature of art and of aesthetic experience, and the question of aesthetic judgement. Some writers have identi-fied the peculiar or essential features of works of art; others have insisted rather on the particular nature of the aesthetic attitude, or the aesthetic experience; and others, sidestep-ping these notoriously difficult problems of the definition of art, have examined the question of the criteria for aesthe-tic judgement. (Wollheim, 1980, presents an excellent review of the major tendencies in aesthetic theory, together with a critique of their respective weaknesses; for contemp-orary work in aesthetics, with the same variety of approach, see Hospers, 1969, and Osborne, 1972. Podro, 1972, dis-cusses some important eighteenth- and nineteenth-century philosophers of art, including Kant and Schiller.) One of the things I shall want to argue in Chapter 4, and indeed something now acknowledged by certain aestheticians, is that it is not possible to separate any 'pure aesthetics' from a sociological understanding of the arts; the question 'what is art?' is centrally a question about what is taken to be art by society, or by certain of its key members. Here, I simply indicate the historical specificity of the rise of aesthetics, which could, no doubt, be related to other social and histor-ical developments of that period (see, for example, Fuller, 1980a, pp. 187–90). This is not to deny, of course, that it is possible to go back further, and discover the 'aesthetic

theory' of Plato or Longinus. It is to emphasise that it was only in the eighteenth century that aesthetics came to be constituted as a distinct discipline, focused solely on art, its objects and their appreciation; within philosophy, these questions were separated from questions of morality and politics, for example.

The constitution of aesthetics as a discipline depended on the prior and accompanying constitution of art itself as a self-contained discourse and practice. By now, many social historians of art and literature have shown how art, literature and the modern conception of the artist/author developed in Western capitalist society. Hauser (1968) traces the rise of 'the artist' (the inspired genius, the sole producer or creator of a work, as opposed to the craftsperson or collective worker), and the separation of art from craft from the fifteenth century in Europe. Raymond Williams has looked at the history of drama, in relation to the changing social relationships and practices within which it has occurred, demonstrating that our contemporary notion of drama (with the particular conventions of theatre, role of the individual actor, and the insulation of the dramatic form from, for example, religious practices) is historically contingent (Williams, 1981, ch. 6; see also Williams, 1965, pt 2, ch. 6). Drama, however, is one of the oldest cultural forms, its various transformations over two thousand years or so linked, as Williams shows, to changes in social relations, modifying rather than constituting the institution. (Similarly, music, another ancient art, has been shown to have changed its form and its conditions of practice in relation to its wider social and political situation; see Weber, 1975). Literature, on the other hand, is a relatively recent cultural form, constituted as distinct from, for example, letter-writing, essays and drama. As Williams says (1977, p. 46), the concept of 'literature' only emerged in the eighteenth century, and was only fully developed in the nineteenth century. In an important article Tony Davies locates the 'fixing' of literature as a clearly, and narrowly, defined institution, comprising 'an ideologically constructed canon or corpus of texts', in England in the 1860s and 1870s. His

argument is that the separation of 'literature' from the multiplicity of written texts was closely connected with the contemporary history and ideology of education, and that both operated in the (fictional) construction of a national unity, which obscured real class antagonisms (Davies, 1978).

The social history of the arts has some serious consequences for the philosophy of art. By relativising their apparently supra-historical status, it puts into question those very works of art which aesthetics generally takes as its unproblematic subject-matter. The social history of art shows, first, that it is accidental that certain types of artefact are constituted *as* 'art' (purely for non-functional purposes, and as distinct, say, from crafts). Secondly, it forces us to question distinctions traditionally made between art and non-art (popular culture, mass culture, kitsch, crafts, and so on), for it is clear that there is nothing in the nature of the work or of the activity which distinguishes it from other work and activities with which it may have a good deal in common. Even those critics and philosophers of art, like Wollheim and Gombrich, who are well aware of the contingent and social nature of artistic practice, invariably take their examples from the 'high arts' (Wollheim, 1980; Gombrich, 1960). But although it may be a relatively straightforward matter to investigate the historical development of 'art' or 'literature', which are indubitably distinct institutions today, it does not follow that discussions about the nature or value of art should similarly be restricted to these historically specific discourses and practices. At the very least, aesthetic theory must consider the question of *why* the 'high arts' appear (if they do) to be the repository of all that is best in art: is it possible to defend a notion of essential, intrinsic quality in certain works (in which case it is surely a coincidence that complex historical and social developments pushed these forward for art history and criticism to recognise and promulgate)? Or do we need instead a sociological aesthetics, which in one way or another goes beyond traditional aesthetics, in much the same way as the social history of art supersedes traditional, intrinsic, art

history? (On the latter development, see Clark, 1973, 1974; Hadjinicolaou, 1978a.)

Moreover, aesthetics can find no guarantee of any corpus of works or canon in art criticism or literary criticism. These discourses, too, are the historically specific product of social relations and practices, and hence as partial and contingent as art and literature themselves. Davies argues that literature, literary ideology (by which he means literary criticism; Davies, 1978, p. 10) and literary history came into existence at the same moment, and that they mutually reinforce one another. Others have also pointed to the ideological (that is, interest-bound) nature of literary criticism from its origins in the nineteenth century up to today (Eagleton, 1976, ch. 1, 1978b; Mulhern, 1979). This is not to denounce criticism, or to reject existing work in favour of some conception of *non*-ideological criticism, for the point is that all criticism is ideological and political (Bennett, 1979, p. 142). The difference between traditional criticism and, say, Marxist criticism is that the former, unlike the latter, refuses to recognise its own perspective and interests, but rather presents itself, in Eagleton's term, as an 'innocent discipline' (1976, p. 11). As Eagleton says (ibid., p. 17):

> Criticism does not arise as a spontaneous riposte to the existential fact of the text, organically coupled with the object it illuminates. It has its own relatively autonomous life, its own laws and structures: it forms an internally complex system articulated with the literary system rather than merely reflexive of it. It emerges into existence, and passes out of it again, on the basis of certain determinate conditions.

Mulhern's recent study of the history of the journal *Scrutiny* and the work of F. R. Leavis (Mulhern, 1979) provides us with an understanding of what these determinate conditions were at a key moment in the history of English literary criticism.

Similarly, social historians of art have exposed the 'noninnocent' nature of mainstream art criticism (Fuller, 1980b,

pt IV; Hadjinicolaou, 1978b; Berger, 1972). As in the case
of literature, criticism is not innocent because it is practised
by particular, institutionally located people (for example,
working in university departments), with specific social
origins and contexts and, hence, specific orientations and
ideologies, using the resources of a given (but continually
constituted) discourse. The discourse of art criticism, like
that of art history, excludes the possibility of a multitude of
perceptions and statements. As Griselda Pollock has said of
art history (1980, p. 57), it

> works to exclude from its fields of discourse history,
> class, ideology, to produce an ideological, 'pure' space
> for something called 'art', sealed off from and impen-
> etrable to any attempt to locate art practice within a
> history of production and social relations.

The same applies to criticism, which presents itself as 'pure'
and timeless, and reacts with outrage to the intrusion of
extra-aesthetic factors into the study and analysis of art.
(See, for example, Gowing's response to John Berger, in
Berger, 1972, p. 107.)

Criticism, and the history of art and literature, then, are
ideological, both in the sense that they originate and are
practised in particular social conditions, and bear the mark
of those conditions, and in the sense that they systematic-
ally obscure and deny these very determinants and origins.
It is for this reason that aesthetics can take no reassurance
from criticism that 'the great tradition' really is great. The
great tradition (in literature, art and any other cultural
form) is the product of the history of art, the history of art
history, and the history of art criticism, each of which, in its
turn, is the social history of groups, power relations, insti-
tutions and established practices and conventions (see
Wolff, 1981). To the extent that aesthetics itself accepts the
false and universalising claims of traditional criticism, its
very project is thrown open to question. To put this rather
simply, the task of discovering the essential common
feature of a Beethoven quartet, *Middlemarch*, Vermeer's

Music Lesson and Chartres Cathedral (so far, as it happens, never achieved) now appears as both ideological and misguided, for why should they have anything at all in common? By a series of historical events and accidents, they have been taken to epitomise the received canons of the arts (canons constructed in ideological and social practices), and assessed in accordance with certain, socially agreed, criteria of excellence.

It may be argued that although both the concept of 'art' and the discourse of criticism are historical and contingent, nevertheless those works of art generally positively assessed by the discipline of criticism do in fact manifest certain universal or transcendent qualities, which explain their persistence through time and their appeal beyond the confines of their own social and geographical origin. Other artefacts, defined as 'non-art' by the processes and discourses referred to, do not have these qualities. On this view, the verdict of criticism, though situated and partial, is in fact right, or objective. It will be appropriate to return to this question of what is involved in aesthetic judgement in Chapter 4. I think we must certainly agree that to demonstrate the origins of a judgement is not (necessarily) to comment on its truth, even if, as Bennett argues, something can only be 'true' within its own discourse: 'A science is the measure both of its own truth value and of what is false in relation to it' (1979, p. 139). Indeed, in the following two chapters I shall be looking critically at the work of those writers who *do* attempt to collapse aesthetic value into social or political values. But what we have so far seen with regard to aesthetics is, first, that as an intellectual practice it, too, has a history; and, secondly, that it takes as its subject-matter artefacts and works which have been produced as the 'great tradition' by the ideological practices of particular groups in specific social conditions. (Although it does not affect my argument, it should perhaps be noted that (*a*) some more broad-minded aestheticians would also include selected works of mass culture – usually the Beatles, jazz, or the 'serious' cinema – in the range of aesthetic objects to be puzzled over; and (*b*) philosophers of the

'aesthetic attitude', including phenomenologists of art, recognise that more or less anything may be perceived in the aesthetic mode, thus also extending the scope of operation of aesthetics, not only to the lesser arts, but also to objects whose primary function may be practical.) For these two reasons, social history and sociology pose a challenge to aesthetics.

The sociology of taste consolidates this challenge. It may be threatening to an absolute aesthetics to have to realise that criticism and its evaluations are ideological. It is probably even worse to learn that values change. But the history of art (of painting perhaps more than of literature, though this may be because the former has a longer history) is also the history of fluctuations in taste and evaluation. It may be possible to argue that our own contemporary taste differs so greatly from that of our Victorian forebears because, for various reasons, they wrongly thought nine-teenth-century academic art was great, when it was not; this is easier than allowing equal weight to both judgements, and it preserves the timeless qualities of truly great art. It is a little more problematic when we consider that work which we now consider to be great art was not always valued as such (Mozart, Matisse, Post-Impressionism, classical archi-tecture), but even here it could be suggested that contemp-oraries were not yet able to appreciate new forms, or had lost the ability to appreciate recently superseded ones. Francis Haskell (1976) documents the substantial and fasci-nating changes in taste from 1790 to 1870 in France and England, showing that these changes in taste are related to wider social factors – religion, politics, museums and tech-niques of reproduction. Haskell concludes his study by confessing to 'a considerable degree of unease' at the impli-cations of the problems he has discussed, for

> although it is possible to avoid the quicksands of total aesthetic relativism by postulating that widening hori-zons and deeper knowledge will eventually lead to the creation of new and more soundly based standards, it is none the less true that every convincing rediscovery has

– to use a repugnant but self-explanatory expression –
involved the acquittal of many 'guilty' artists in order to
free the few candidates who are worthy of serious recon-
sideration. (Haskell, 1976, p. 180)

The first part of this sentence sounds rather more hopeful
than convinced, and I doubt whether 'widening horizons'
or 'deeper knowledge' will be much help. Apart from any-
thing else, they would not be able to explain *reversals* of
taste. In general, I think it is clear that we cannot use the
vantage-point of the present to pretend to any final assess-
ment (though we *can* often perceive the particular ideolog-
ical nature of earlier judgements).

The sociology of contemporary aesthetic taste reveals a
plurality of criteria and valuations within one society at a
given moment. If it is the case, as those I have referred to
earlier argue, that the accepted aesthetic judgements are
merely those of strategically located groups of people
(academics, intellectuals, critics, and so on), then we shall
not be surprised to find that other members of the popula-
tion have entirely different taste in culture. Bourdieu's
'social critique of judgement' (1979) exposes the class-
based variety of aesthetic preferences, in six hundred or
more pages which contain few revelations. (Teachers in
higher education prefer 'The Well-Tempered Clavier' to
'The Blue Danube', whereas labourers prefer the latter:
Bourdieu, 1980, p. 229.) As the subtitle of his book indi-
cates, Bourdieu's project represents a critique of Kant's
own aesthetics, *The Critique of Judgement* (1952), and
specifically of the notion of 'disinterestedness' as character-
ising the aesthetic disposition.

Every essentialist analysis of the aesthetic disposition . . .
is bound to fail. Refusing to take account of the collect-
ive and individual genesis of this product of history
which must be endlessly re-produced by education, it is
unable to reconstruct its sole *raison d'être*, i.e. the histor-
ical reason which underlies the arbitrary necessity of the
institution. (Bourdieu, 1980, p. 234)

It is certainly true, as I have already indicated, that the 'disinterested aesthetic disposition' itself has a history, and that it can only be understood in terms of its specific moment of emergence. It is also true that the category of 'the aesthetic', the separating-off of art from other aspects of social and practical life, is a social-historical construct, and in this sense, as Bourdieu says, 'arbitrary'. The point, however, is that this does not solve the problem of aesthetic value. Later in his discussion, Bourdieu counter-poses the 'popular aesthetic', which combines a reference to the functional relevance of a work with its appreciation, to the traditional 'pure' aesthetics, whose disinterestedness explicitly excludes the functional or extrinsic from judgement. but while it may be the case that these two contrasting aesthetics are class-based (in the complex, and interesting, way that Bourdieu suggests), this would not be a reason to substitute the popular aesthetic for the traditional. Again, it may still be possible to argue that the aesthetic disposition with its associated judgements, which has, certainly, emerged in certain historical and social conditions and continues to have a particular (class, or other) location, is the appropriate mode for the appreciation of art and the only basis for its assessment *as* art. But this comes back again to the question of what 'aesthetic value' *is*. Are there any grounds to continue to argue that 'The Well-Tempered Clavier' is better than 'The Blue Danube'? Or does the sociological critique of judgement inevitably lead either to a populist aesthetic (the 'best' work is what most people, or the dominated classes, like – see Taylor, 1978), or to the complete aesthetic relativism feared by Haskell, with no attempt to claim absolute, suprahistorical value for any works of art? In a way, this is the aesthetic version of the problem of the genetic fallacy, for the sociologist of art must decide whether the fact that the genesis of an aesthetic evaluation can be accounted for in itself invalidates that evaluation. But if it is argued that it does not necessarily invalidate the evaluation, the question of the criteria of judgement is posed even more sharply, since we can no longer adopt uncritically the self-perpetuating discourse of aesthetic judgement.

My main argument in this book is that we need to rescue some concept of the aesthetic both from the imperialistic claims of the most radical sociology of art which would equate aesthetic value with political worth, and also from the total relativism and incapacity into which the self-reflexivity urged by the social history of the arts and of criticism might lead aesthetics. In the rest of this chapter I shall give some preliminary indications of why I believe this is necessary, but before I do so, it might be helpful to clarify the sense(s) in which I use the word 'aesthetic' (without, however, anticipating the discussion in Chapter 4, where I consider some issues in aesthetic theory). Although, as I have said, the central concern of this book is the concept of 'aesthetic value', in so far as this is affected by the sociology of art, it is already clear that I am also involved in debates about 'aesthetic experience'. As I have argued elsewhere (Wolff, 1981, pp. 141–3), in one sense the aesthetic sphere is not problematic. That is to say, the discourse of the aesthetic is already, historically, constituted; we have the institutions, objects and practices of the arts (not always clearly defined or bounded, it is true), and the accompanying disciplines of art history, literary criticism and aesthetics itself. Although it is possible, and from our point of view essential, to interrogate this discourse and expose the structures and social relations in which it has been constructed, the discourse and its practices confront us as a 'social fact'. So if by 'aesthetic' we simply mean paintings, novels, museums, publishers, critics, historians of art, philosophical theories of art and all those other elements which comprise, and are comprised in, the discourse of the aesthetic, then there are no difficulties, apart from practical ones, in identifying this sphere and its operations. More problematic, however, are the two, linked, issues of the 'aesthetic experience' (of the 'aesthetic quality' of works) and of 'aesthetic value'. The reason why any discussion of the latter also involves the former is that if we refuse to reduce aesthetic value to, say, political or moral value, then we immediately appear to defend the specificity of art, whether this is conceived as a particular kind of aesthetic experience, or a particular

quality inherent in certain artefacts. If a good novel is not good simply because it is politically correct, or morally admirable, or useful for any extraneous purpose, then we are saying it is good *as a novel*, or *as a work of art*. Aesthetic evaluation, then, will involve taking a position on the nature *of* the aesthetic. (The way I have presented this, however, ignores the implications of Bourdieu's argument, which may be that in saying that a novel is 'good' we can only mean that many people, or perhaps the right people, like it. But I shall come back to this view in Chapter 3.) Possibly 'aesthetic' will turn out to mean nothing more than, for example, the rules for novel-writing (which, in the case of a good novel, are therefore followed well or success-fully). In any case, the question of the specificity of the aesthetic is necessarily central to the question of aesthetic value.

The sociological perspective on the arts can be traced back at least to some unsystematic comments by Marx and Engels, as well as to the work of other early, but more idiosyncratic, writers like Taine and even Max Weber – idiosyncratic in the sense that they have not given rise to or formed part of a tradition of a sociology of art. It was then developed through early Soviet aesthetics and the writings of members of the early Frankfurt school, as well as those of Caudwell, Fox and others in Britain in the 1930s, and greatly advanced during the recent growth in cultural studies and the sociol-ogy of literature in Britain and elsewhere. This work has produced a valuable, and increasingly sophisticated, set of tools and theories which help us understand the arts better. I include in this development the work of social historians of art and literature such as Hauser, T. J. Clark and Raymond Williams, for their concerns and contributions seem to me to merge with those of sociologists – that is, into a body of work on the social and historical production of the arts, their conditions of production and consumption and the forms and codes of representation in which they reproduce ideology. Both have achieved the important result of demystifying art and exposing the myth of the

artist as 'genius' by demonstrating on the one hand the his-
torical particularity of both 'art' and 'artist' and on the
other the ideologies and interests implicated in the produc-
tion and assessment of the arts. The relative invisibility of
women in the history of the arts is no longer put down to
their inability to paint or compose music, but is comprehen-
ded in terms of the structures of those worlds of art and
music which exclude women from training and success by
various direct or indirect means; and in terms too of the
sexist practices of art history and art criticism (see Parker
and Pollock, 1981; Pollock, 1979). But some writers are
beginning to wonder whether we have over-sociologised our
material. Too often the critique of art as ideology seems to
have resulted in the disappearance of art as anything *but*
ideology, and there are many reasons why this kind of
reduction will not do.

In the first place, there is the well-known problem (per-
haps first raised by Marx in his unsatisfactory reflections on
why Greek art still appealed to nineteenth-century audien-
ces) of the persistence of some works beyond the operation
of their own social and ideological structures. However,
attempts can be made to explain this within the theory of
ideology: different ideological readings, or sufficient simi-
larities in class divisions, and so on. Secondly, many kinds
of work do not seem amenable to sociological analysis
(chamber music and abstract art, for instance), except in the
sense of examining the social conditions of their appearance
and success. Although attempts have been made to identify
the ideological aspects of even these most resistant forms
(see, for example, Fuller, 1980b, pt I), it is precisely in such
cases that it becomes clear that the 'residue' is significant. It
may be, as Fuller argues, that Robert Natkin's paintings are
politically or ideologically superior to the work of other
contemporary American painters, because, as he says, they
induce the viewer 'into an order of experience beyond the
"purely visual"' (ibid., p. 94), but it is also possible to ask,
as Fuller himself has recognised in other recent writings,
whether and how the 'purely visual' is itself pleasing, or
successful. Thirdly, there is then a problem when we

discover that work pronounced ideologically incorrect or unsound is found to be enjoyable, technically excellent, or in some other way 'aesthetically' good. This is less likely to occur, of course, in the case of an abstract painting (whose ideology in any case takes a considerable amount of analytical effort to elicit) than in the case of, say, a fascist novel. Two examples which come to mind are, first, the classical ballet, many of whose major works of repertory are based on reactionary and sexist (not to say silly) stories, and secondly, the paintings of Emil Nolde, a German expressionist painter who was a Nazi sympathiser (Royal Academy of Arts, 1979, p. 174). It so happens that my critical 'reading' of those ballets does interfere with my enjoyment of their performance, though it is still possible to appreciate skill, design and choreography of parts of the works, whereas in the latter case the extraneous knowledge does not affect my appreciation of Nolde's paintings. Since it does not, what is it that I am appreciating? (Obviously, we should not be likely to discover that Nolde's Nazi sympathies were somehow manifest in his work; but in that case, ought I to be looking for some alternative ideological content, which would explain my positive reactions?) I shall come back to this problem in the next chapter, when I consider the view expressed by Hadjinicolaou that 'the pleasure felt by the spectator on viewing a picture, and the correspondence of his aesthetic ideology to the picture's visual ideology, are one and the same thing' (1978a, p. 180).

For all these reasons, a number of people have begun to argue that we must, after all, reinstate the aesthetic, if not in its traditional, essentialist form, at least in some acceptable sociological or materialist terms. The last great work of Georg Lukács, one of the major figures in the sociology of art, was on the nature of the aesthetic (Lukács, 1963). Although critics and commentators have concluded that his attempt to specify the peculiarity of the aesthetic returns him to the idealist, un-historical, analysis of his early pre-Marxist writings (see Lichtheim, 1970, p. 128; Williams, 1981, p. 128), the very attempt signifies his dissatisfaction with reductionist theories of art, and for that reason is an interesting direc-

tion for students of his work. Others have written more recently proposing the development of a new theory of aesthetics, and in some cases criticising their own earlier work. For example, Fuller (1970c, p. 13) says:

[The] occlusion of aesthetic sensitivity is itself ideologically determined: it involves capitulation to a reductionist way of seeing peculiar to the culture of the prevailing economic order.

Raymond Williams (1979, p. 325) makes the following, rather guarded, comment:

Even with the category of the aesthetic, I say it is wholly necessary to reject the notion of aesthetics as the special province of a certain kind of response, but we cannot rule out the possibility of discovering certain permanent configurations of a theoretical kind which answer to it.

Terry Lovell (1980, p. 95) argues that a sociology of art must be concerned with the analysis of social pleasures:

The discerning of aesthetic form itself must be seen as a major source of pleasure in the text . . . Aesthetic sensibilities are class- and sex-linked, and the politics of aesthetic pleasure will depend on the particular ways in which that sensibility has been appropriated and developed along lines of sex and class.

And Terry Eagleton, in his most recent book (1981), asks the very pertinent question, in relation to Lukácsian sociology of art which approves 'realist' texts, 'Why *should* accurate cognition and representation of the real afford aesthetic gratification?' (p. 84; emphasis in original).

As I shall argue in Chapter 5, recognition of this problem has led different writers to a variety of attempted solutions, including the use of psychoanalysis and philosophical anthropology. It is by no means agreed *how* sociologists or Marxist aestheticians should conceive of 'aesthetic

gratification' or 'permanent configurations', or even what these may be. In the following pages I shall try to show that the sociology of art has inevitably raised this as an issue, acknowledging that the critique of reductionism means not only allowing the relative autonomy of art (to develop at its own pace, to play its own part and demonstrate its own effectivity in the historical process – see Wolff, 1981, ch. 4), but also contemplating the possibility that 'the aesthetic' has its own irreducible specificity.

In Chapter 2 I consider a number of different responses to the apparent counter-position of aesthetics and the sociology of art, ranging from the rejection of the latter or refusal to see it as any kind of threat to aesthetics, to the most radical sociologistic account, which collapses aesthetics into politics or ideology. Then in Chapter 3 I go on to discuss the question of value in general, in order to look at the particular problems of theories of aesthetic value, and here the possibility of separating aesthetic from political value is raised. Chapter 4 takes issue with some traditional theories of art, arguing that a 'pure', non-sociological aesthetics is impossible. In Chapter 5 I examine some of the attempts to posit the specificity of art within a sociological perspective, reviving thereby the project of an aesthetics, but one which is no longer hindered with essentialist or idealist assumptions. Chapter 6, the final chapter, attempts to summarise these debates, and to suggest the outlines for a sociological aesthetics.

2

Sociology versus
Aesthetics

Sociology implicitly, and sometimes explicitly, presents a challenge to traditional aesthetics. There are a number of ways of responding to that challenge, and in this chapter I shall consider the adequacy of some of these. In doing so, I use both terms—'sociology' and 'aesthetics'—with rather broad connotations. 'Aesthetics', as I indicated earlier, includes theories about the nature of art as well as about the criteria of aesthetic judgement. 'Sociology' here includes a variety of approaches to the arts which insist on comprehending them in their social and historical location, seeing them as constituted in specific conditions and practices of production and reception; thus besides the academic discipline of sociology, I refer to the social history of art or literature, and also to some hermeneutic approaches.

The first reaction to the sociological challenge is the conservative defence of aesthetics, based on a denial of the importance or relevance of the sociology of art. On the whole, in fact, the discipline of aesthetics continues to be conducted without reference to the intervention of sociologists. (See, for example, the essays in Osborne, 1972, or in Hospers, 1969, as well as journals like the *British Journal of Aesthetics*.) Mainstream Anglo-American philosophy of art pursues its search for the nature of beauty and of the aesthetic experience without in any way being disturbed by the sociological critique of aesthetics itself as a historically specific development, and of all aesthetic judgements as class-based, gender-linked and in general ideologically produced. However, one or two philosophers of art have

accepted the challenge, only to assert that the intruder is hardly worth bothering about. This takes the form either of claiming that the sociological project is misconceived or of insisting on the limits to sociological competence, the latter being the more usual method of neutralising the challenge. Authors will thus acknowledge that art is a social product, and that sociological analysis can illuminate some interesting things about it. But they deny that this sort of knowledge can affect the central core of aesthetics, that is, the question of aesthetic value or experience.

In some cases the attack on the pretensions of sociology is in fact directed at an earlier perhaps cruder, model of analysis (for example, Gombrich's review of Hauser's *Social History of Art*, Gombrich, 1965, and Wollheim's comments on some early work in the social history of art, Wollheim, 1970), in which case their objections to a simple reductionism may be well-founded. But more recent, and more sophisticated, work in the sociology of art, which does not simply relate art to class or to ideology in a simple one-to-one formula, also comes under attack for its refusal to respect the autonomy of the aesthetic. Gombrich, in an essay extremely sympathetic to the role of the social sciences in art history, says (1975, p. 42):

> It is when we come to this question concerning value, questions which are and will remain vital to the art historian, that the social scientist would, I think, have to refuse to be drawn ... As a social scientist he must confine himself to social evidence, and this evidence can, in the nature of things, have no bearing on values.

He concludes that the social scientist 'will have to rely on the art historian who is the keeper of the canon', that 'The social scientist can assist the art historian, he cannot replace him' (ibid., p. 57).

But we have already seen that it is highly problematic to accept this 'canon' uncritically, for, as social science itself makes clear, the art historian who is supposed to have this peculiar, professional access to 'values' is in fact operating

within ideologically constructed discourse, and from an ideological position (that is, class-bound, institution-based and biographically influenced). The only thing the social scientist might lack, *vis-à-vis* the art critic or art historian, is a certain training in the languages of art, in iconography, or in other forms of knowledge which inform perception. Apart from this, art history has no better claim to objectivity in the defence of values than sociology, which at least exposes the origins and interests involved in aesthetic judgements.

In philosophical hermeneutics, Hans-Georg Gadamer's (1975) argument against the Kantian notion of the aesthetic experience as timeless and disinterested has been opposed by Oskar Becker (1962). Gadamer argues that the unmediated aesthetic consciousness is an illegitimate abstraction, in the light of the fact that both the work of art and its appreciator are historically situated. The aesthetic dimension is necessarily transcended in any encounter with a work of art. Becker objects that the historicity of works and viewers is contingent and irrelevant to the aesthetic experience, which consists precisely in those aspects which themselves transcend the historical.

> The aesthetic dimension cannot legitimately be overstepped. For the 'transparency' of the work of art does not lead to some extra-aesthetic *content*, but to the idea which, according to its essence, is always *form*. (Becker, 1962, p. 236; emphasis in original; my translation)

Again, we find the defence of the aesthetic which relies on a pre-sociological notion of its particularity.

In some cases the rejection of the sociology of art results from a misunderstanding of its project or of its implications. For example, David Caute once criticised Goldmann's sociology of literature, which shows how works of literature represent the ideology of the social group of which their author is a member, the most successful and respected of Goldmann's works on these lines being his study of seventeenth-century French society and literature (Goldmann, 1964). Caute (1974) objects that such a theory has no room for the author,

who is seen as no more than the 'midwife' assisting at the birth of a text; its true parent becomes the class or social group, whose world-view is expressed in the work. I have argued elsewhere (Wolff, 1981, pp. 67–70) that the sociology of art or literature, in drawing attention to the structural determinants of works, is not thereby eliminating authors; in Goldmann's work, for example, there is a great deal of information about Racine's specific experience and mediation of the position and world-view of his social class, refracted through personal and biographical factors. But in any case, to reject the sociology of art on the ground that its central focus is not on individuals seems to be to prefer a psychology of art to a sociology of art. It is unclear how the former would avoid the dangers of reductionism of which the latter is accused, for in this case aesthetic experience or judgement would be a matter of subjective, individual taste. Wollheim appears to hold the same view about the necessity for a psychology of art.

> In relating works of art *directly* to social conditions, we should be omitting all reference to psychological factors and so, by implication, asserting these factors to be of no relevance to the understanding of art. But such a suggestion must be repugnant to all. Indeed it seems that particular sociological explanations are likely to be acceptable only to the degree to which interpolation of psychological factors between the social conditions and the works of art is easy and natural: that is to say, to the degree to which as explanations they cease to be sociological. (Wollheim, 1970, p. 575; emphasis in original)

Although Wollheim is here talking specifically about *causal* explanations, and not about all types of sociological explanation, I think he too mistakes the importance of sociology in this enterprise. Even in relating works of art to social conditions (directly or indirectly), we still recognise that they are produced by (socially located) individuals or groups of individuals, and a comprehensive sociology of art will pay due attention to the mediation of social and

ideological influences through individuals. (Whether this involves psychology, however, is another matter.) Moreover, it is not the case that in so far as such explanations pay attention to individuals they cease to be sociological, for even psychological accounts of the artist as producer cannot stand on their own, as if the artist is somehow remote from his or her social and historical situation.

The defence of the specificity of the aesthetic which works by barricading the arena of 'art', the 'artist' or 'creator', 'values' and 'form' against the incursion of a sociological critique is an unacceptable one. It succeeds only in demonstrating its own failure to understand the problems with such concepts which social history has exposed. By refusing to see that those 'values' supposed to inhere in certain works, accredited by members of the profession of art history and criticism, are in fact open to critical examination, the conservative defenders of the realm of the aesthetic preserve only a weak and vulnerable notion of aesthetic value and artistic creativity.

At the other extreme, the second response to the challenge of the sociology of art is to accept it wholeheartedly, to the extent of denying totally *any* category of 'the aesthetic'. There are various kinds of such sociological reductionism. They have in common the fact that they believe the problems of aesthetics have been solved, once we see that the production, reception and assessment of art are always socio-historical events. 'Aesthetics' is simply an existing, historically specific discipline; 'aesthetic experience' is explicable in terms of ideology and political values; and 'aesthetic evaluation' is nothing but a function of one's class or other interests.

I have already referred to Hadjinicolaou's view that the pleasure involved in viewing a picture is merely the coincidence of the ideology of that picture with that of the viewer (page 24 above). Hadjinicolaou (1978a) presents an excellent critique of the traditional disciplines of art history and art criticism, and demonstrates the way in which we must perceive paintings *as* ideological. He does this, with illumi-

nating examples, without ever resorting to the kind of reductionism which simply relates style or content to class ideology, but shows rather that class divisions are themselves complex, and that the way in which paintings manifest ideology is mediated by the language of visual representation itself. This language, or what he calls 'visual ideology', cannot be deduced from class ideology (ibid., p. 96), for Hadjinicolaou is concerned to stress the specificity of art (p. 97). His analysis of paintings as visual ideology pays close attention to details of style and composition, for it is in these representational features that ideology is produced. When he goes on to discuss aesthetic value and aesthetic 'effect', however, his account becomes more reductionist, for his materialist analysis of art leads him to conclude that aesthetic judgements derive from the aesthetic ideologies of social groups.

> In practice this means that from now on the idealist question 'What is beauty?' or 'Why is this work beautiful?' must be replaced by the materialist question, 'By whom, when and for what reasons was this work thought beautiful?' (ibid., p. 183).

The analysis of statements about aesthetic value must be in terms of the conditions of production of the particular works, and in terms of the history of their reception and appreciation (see also Hadjinicolaou, 1978b).
 Terry Eagleton has argued in similar terms, in connection with the critique of literary history:

> There is no 'immanent' value. . . . Literary value is a phenomenon which is *produced* in that ideological appropriation of the text, that 'consumptional production' of the work, which is the act of reading. It is always *relational* value . . . The histories of 'value' are a sub-sector of the histories of literary-ideological receptive practices. (Eagleton, 1976, pp. 166–7; emphasis in original)

Eagleton's view, at least in *Criticism and Ideology* (1976), is that the problem of value is dealt with only by a science of

the ideologies of value, together with a science of the ideo-
logical conditions of the production of value (p. 168). But
this, too, is to reduce aesthetic value to aspects of ideology,
albeit materially and historically produced ideology. He is
right, of course, when he remarks that bourgeois criticism
cannot answer the question of why or whether Yeats was a
great poet, except with 'intuitionist rhetoric' (p. 179).
Nevertheless, his conclusion, that 'the value of a text . . . is
determined by its double mode of insertion into an ideolog-
ical formation and into the available lineages of literary dis-
course' (p. 186), appears to dodge the crucial issue which
his latest work acknowledges as a problem, namely, why
particular ideologically produced texts should afford
aesthetic gratification (see page 25 above). Although it is
essential to analyse the ideological components both of the
text and of its appreciation, there remain the questions of
whether there are certain specifically 'aesthetic' qualities to
texts, and certain peculiarly 'aesthetic' criteria of evalua-
tion of those texts. The suggestion that value resides, in
however complex a way, in ideology – that it is wholly
reducible to ideology – is an inadequate and unsatisfactory
solution to the problem.

An additional sort of sociological reductionism of the
question of aesthetic value is found in varieties of 'reception
aesthetics'. Proponents of this theory usually base their
critique of traditional aesthetics on the argument that the
text (or painting, or any cultural work) has no fixed mean-
ing, but that meaning is produced by the viewer/reader with
every act of reception. Viewing or reading is always (re-)
interpretation, from the particular perspective of the viewer
/reader. (The more sociological proponents of reception
aesthetics naturally perceive this interpretation as produced
in social – class, gender, and so on – conditions.) Reception
aesthetics here includes hermeneutics and semiotics, as well
as the approach that explicitly labels itself 'reception
aesthetic' (see Wolff, 1981, ch. 5). The implications for the
question of value are not obvious, but one suggestion,
made by Hans Robert Jauss, may be considered.

Jauss argues that the literary canon is produced in the

history of a work's critical reception, the appreciation of the first reader being continued and enriched through successive receptions (1970, p. 8). Against the 'prejudices of historical objectivism', he proposes an aesthetics of reception and impact (p. 9). Since literary works appear differently to consecutive readers, their evaluation is reproduced at each reading.

> A literary work is not an object which stands by itself and which offers the same face to each reader in each period. It is not a monument which reveals its timeless essence in a monologue. (ibid., p. 10).

He points out, obviously rightly, that any work continues to have an effect only if future generations still respond to it or rediscover it. Any particular aesthetic judgement or effect, he maintains, is a function of the 'horizon of expectations' of the audience for a work. New works will have greater or lesser aesthetic distance from the horizon of expectations of their readers, in some cases (the example he cites is *Madame Bovary*) producing such great aesthetic distance that only a few readers know how to understand the work. In the longer term, however, such works may transform reading in general, as well as the literary canon itself. Jauss is prepared to define aesthetic value in terms of these features of reception.

> The way in which a literary work satisfies, surpasses, disappoints, or disproves the expectations of its first readers in the historical moment of its appearance obviously gives a criterion for the determination of its aesthetic value. The distance between the horizon of expectations and the work, between the familiarity of previous aesthetic experiences and the 'horizon change' demanded by the response to new works, determines the artistic nature of a literary work along the lines of the aesthetics of reception: the smaller this distance, which means that no demands are made upon the receiving consciousness to make a change on the horizon of unknown

experience, the closer the work comes to the realm of 'culinary' or light reading. (ibid., pp. 14–15)

Unlike the sociology of art and literature which defines aesthetic value in terms of the ideology of a work's producer or, as in the case of Hadjinicolaou, in terms of the interaction between the ideologies of viewer and text, reception aesthetics thus often equates value with quality of response, ignoring all questions of intentionality or possible textual autonomy. It does not lapse into total relativism or subjectivism, since value is construed as the historical and cumulative construction of successive audiences. A weakness in Jauss's account is that the originality which confounds or challenges expectations consists for him solely in literary form, or at least so his discussion of Flaubert (1970, pp. 17–18) suggests; but it would certainly be possible to widen this to include the representation of ideas, plot, narrative, and so on, within this form. The question is whether even this is an adequate account of what is involved in aesthetic evaluation. Judgement is still relative, though not on an individual basis, having no guarantee outside the audiences who value the work. There is certainly no question of transhistorical or universal human features which explain the persistence of many works over centuries and across cultures. But then perhaps such works can be seen to continue to challenge expectations, possibly offering different challenges to succeeding generations as a result of their complexity.

Nevertheless, though any aesthetics necessarily has to be an aesthetics of reception (for value *is* only accorded by those who experience the work), and although Jauss's analysis allows us to perceive reception as itself ideological (since it is defined in terms of existing horizons of expectation), reception aesthetics remains a partial account of both aesthetic experience and aesthetic evaluation. For the existence of a 'great tradition' is still made to appear relatively unproblematic, as long as we fail to see the specific material and ideological practices in which works are produced in the first place (the sociology of literary production), those

conditions and practices which locate certain people or groups *as* audiences and, particularly, those key members of audiences whose task it is to formulate and conserve the literary heritage (the sociology of reception and of criticism). This criticism does not refute Jauss's view that value consists in the transformation of expectations, though it does emphasise that the meeting between expectations and texts is historically and contingently manufactured. But we still need to investigate just how or why certain works challenge audiences in certain conditions, and why such a challenge is aesthetically 'satisfying'.

I have already referred to Bourdieu's work on the sociology of taste in the previous chapter. As I said, he wishes to replace traditional, Kantian aesthetics with a 'popular aesthetic'. His work is a study of all those things which are missing in Jauss's account: the production of differentiated audiences in concrete historical and social processes, and the differentiation of taste as intimately connected with social and cultural relations of power (Bourdieu, 1979). He shows how the dominant theories of art in Western society reinforce the social divisions in society, being part of the 'cultural capital' deployed by the intellectuals of the dominant class to reproduce the distinction between itself and the dominated class (and also in their struggle with the dominant section of their own class, those owning economic rather than cultural capital – see Garnham and Williams, 1980, p. 219). The very possibility of the aesthetic disposition, as 'disinterested' and separated from practical concerns, depends on the privileged conditions of existence of the dominant class which secure it 'objective and subjective distance from practical urgencies' (Bourdieu, 1980, p. 251) by suspending or removing economic necessity. So the possibility of such aesthetic appreciation, as well as its specific assessments, is class-bound and partial. The 'popular aesthetic', on the other hand, refuses the criterion of disinterestedness. The working class subordinates form to function and substance. For those in the dominated groups of society, excluded from the operation of aesthetic distanciation,

however perfectly it performs its representative function, the work is only seen as fully justified if the thing represented is worthy of being represented, if the representative function is subordinated to a higher function, such as that of capturing and exalting a reality that is worthy of being made eternal. (Bourdieu, 1980, p. 246)

Bourdieu gives examples of assessments of photographs, which he maintains are always based on extra-representational criteria:

Thus the photograph of a dead soldier provokes judgments which, whether positive or negative, are always responses to the reality of the thing represented or to the functions the representation could serve, the horror of war or the denunciation of the horrors of war which the photograph is supposed to produce simply by showing that horror. (ibid., p. 244)

This aesthetic, which is, from the point of view of pure aesthetics, 'barbarism *par excellence*' (p. 246), reduces works of art to things of life, form to human life.

Now it is quite true, as Bourdieu shows, that the 'pure' disposition which is accepted as universally legitimate is both class-bound and the object of struggle between classes; it is used as a strategy of exclusion and 'distinction' by members of a higher class against those below them. Though there are numerous difficulties with Bourdieu's own classification of groups, and more particularly with their transposition from France to Britain or elsewhere (see Mary Douglas's review article, 1981), the sociological analysis of 'judgement' on such lines clearly throws into question once again traditional aesthetics and its universalising tendencies. It does not, however, substitute another aesthetic. As I said earlier (p. 20), exposing the genesis and ideological operation of traditional aesthetics does not in itself invalidate it. Indeed, if there is good reason to insist on the specificity of the aesthetic, it is unlikely that the popular aesthetic, which reduces or relates art to extrinsic

factors, can account for it. Bourdieu would no doubt reply that in that case the search for the specificity of the aesthetic is itself simply the reinforcement of the class-based cultural distinction. But, as Mary Douglas points out, Bourdieu 'is not revealing the epistemological shakiness of a theory of aesthetic judgment, but attacking its exploitation for social purposes' (Douglas, 1981, p. 164). For us the question remains of the particular character *of* the (bourgeois) aesthetic distinction. As another type of reception aesthetic (that is, an approach which perceives aesthetic judgement solely in terms of who is doing the judging), Bourdieu's critique manifests the same weakness as all those theories, and indeed as any sociological reductionist account. It fails to answer the question, by refusing to consider it, of the peculiar nature of aesthetic experience.

The third type of response to the sociological critique of art and aesthetics is one which asserts the social and ideological construction of art, but then argues that art, or 'good' art, transcends its conditions of production. The dilemma of choosing between an uncritical idealist aesthetics and sociological reductionism is avoided by opting for some notion of the particular exemption of art in certain circumstances. Here I want to consider the use of this strategy in the very different theories of Lukács, Marcuse and Althusser.

In *History and Class Consciousness* (1971a) Lukács demonstrates the fragmentation of thought and experience under capitalism. He shows how a society based on commodity fetishism and the advanced division of labour produces a reified and fragmented vision for its members, who are no longer in a position to comprehend the totality of their society or of the real relations and structures on which it is based. The analysis in Marx's *Capital* of the dominance of the commodity form is extended into a critique of consciousness. Lukács argues that it has become impossible for those living under capitalism—bourgeois and proletarian alike—to penetrate the phenomenal forms in order to grasp the economic processes and determinants of that thought.

Unlike the bourgeoisie, the proletariat has an objective interest in overcoming reified thought, since commodity fetishism and fragmentation do not operate in its interests (ibid., p. 149). The task for the proletariat is to rediscover the 'totality'—the underlying structure and its logic. For Lukács, as for Marx, these are essentially material and economic factors, whose operation can be seen to produce the specific forms of consciousness of bourgeois society. Lukács makes it clear that the totality can only be grasped via its 'mediations', which are the processes by which the underlying structures are transformed into categories of thought. (Here, as elsewhere, he is strongly opposed to any attempts at a nonmediated, or *im*mediate, grasp of the totality, which he sees later as leading to the unreason of fascist thought and the idealisation of false totalities; see Lukács, 1980.) The development of class-consciousness among the proletariat is thus the discovery of the mediating categories which disguise real relations with reified forms.

All of Lukács's later work on aesthetics and literature, which occupied him for most of the rest of his life, from the first publication of *History and Class Consciousness* in 1923 until his death nearly fifty years later, depends on this notion of the 'totality' which is opposed to reified thought. Good literature is that which portrays the totality, and which is thus, in Lukács's particular sense, 'realistic'. Realist art makes the necessary link between appearance and reality, presenting, in fictional form, the real relations and structures of its society. Unlike naturalist literature, which is content to describe in minute detail, without penetrating to the hidden and determining features of social life, realism selects and presents the 'typical', thereby disclosing the fundamental social and political forces at work in society (see, for example, Lukács, 1970). Many of Lukács's arguments and assumptions have now been subjected to extensive debate and controversy: the notion of realism itself, the rejection of modernism as a politically and aesthetically valid form, the rather idiosyncratic preference for some authors over others, and so on. The issue I want to explore here is that of the nature *of* art which underlies Lukács's

work, and which produces art or literature as suitable, or even possible, vehicles for the critique of capitalism envisaged.

Even in *History and Class Consciousness*, a work in politics and philosophy which is not concerned with aesthetics, Lukács suggests the special role art can play in the consciousness of the proletariat. Searching for the non-fragmented, totalising vision, he remarks (1971, p. 137):

> We are dealing with an attitude . . . which need not be sought in some mythologising transcendent construct; it does not only exist as a 'fact of the soul', as a nostalgia inhabiting the consciousness, but it also possesses a very real and concrete field of activity where it may be brought to fruition, namely art.

He goes on to identify the theoretical and philosophical importance of the 'principle of art', as follows:

> This principle is the creation of a concrete totality that springs from a conception of form orientated towards the concrete content of its material substratum. In this view form is therefore able to demolish the 'contingent' relation of the parts to the whole and to resolve the merely apparent opposition between chance and necessity (loc. cit)

He proceeds to criticise this conception of art in the works of Schiller, Hegel and Fichte, which only demonstrate the *need* for a totalising vision in the face of increasing fragmentation. Their particular theories of art he finds inadequate, since they 'mythologise' the process of creation (p. 140), rather than pursuing the real task, which is to deduce the unity of the fragmented subject. His argument here is very condensed, and immediately afterwards he drops the question of the aesthetic, so it is not entirely clear what his view is on this subject. In the context of the discussion, he seems to be arguing against false totalities, which are not based on a proper analysis of art or creativity, but

which invoke the aesthetic more or less in desperation as an apparent resolution of the problem of fragmentation, for 'In the aesthetic mode, conceived as broadly as possible, [all the contents of life] may be salvaged from the deadening effects of the mechanism of reification' (ibid., p. 139). So the totalising view of art is itself explained as a reaction to reified existence, while its specific notions of totality are rejected. Nevertheless, Lukács does not seem to reject the *idea* that art can produce the right totality and, as we have seen, all his later work is premissed on just such a belief.

There are two aspects of the question of how art may represent a totalising vision in a fragmented society. The first is the need to explicate the specific historical conditions in which art, or particular artists, may be able to attain this vision. The second is the more fundamental question of the peculiar nature *of* art which renders it available for the transmission of such a vision. Lukács gives some attention to the first of these, arguing, for example, that it was only in the progressive stage of capitalist development that writers could perceive and expose the nature of their society (see Lovell, 1980, p. 73). Even here there are problems, as when Lukács argues (with Engels's views as confirming authority on this) that even non-progressive participants, like the royalist and reactionary Balzac, can comment on their particular 'totality'. As Lovell (1980, p. 74) points out, this is inconsistent with Lukács's own view, as expressed in *History and Class Consciousness*, that the condition of realism and truth was involvement with the standpoint of the proletariat; perhaps, in the case of the rise of capitalism, the equivalent should be the standpoint of the emerging and revolutionary bourgeoisie – but certainly not the apologists for the old regime. Lukács maintains that after the consolidation of the bourgeois ascendancy in 1848 it was no longer possible for great realist novels to be produced in the West, for the totalising vision involved in the revolutionary overthrow of the existing society was now dispersed, replaced by the conservative, and increasingly reified, thought of a new dominant class.

This provides some important ideas for the analysis of

critical literature, including socialist literature, and does admit recognition of the necessity to incorporate an understanding of the conditions of criticial consciousness into the sociology of literature. But it does not take this far enough. The sociological project is thus not followed through, in so far as Lukács does not provide a systematic account of the production of authors and the production of novels, analysing the class position of realist writers and their particular historical consciousness. Nor does he explain why, at certain moments and in certain social conditions, the literary mode of production allows the critical consciousness expression. But this leads to the second point.

Lukács never really resolves the problem of the peculiar nature of art, which makes it an appropriate discourse for the expression of critical, realist consciousness. Some commentators have argued that his faith in art to fill this role goes back to his pre-Marxist writings on art (particularly *Soul and Form*, Lukács, 1974, and *The Theory of the Novel*, 1971b), in which he reproduces the idealist and romanticist view of art as 'the privileged repository of authentic human values' (Lovell, 1980, p. 74; see also Lichtheim, 1970, pp. 94–5). The belief in art as potentially producing knowledge of the real is thus an inadequately examined presumption in his later work, although realism is now given a more materialist definition. Whatever the reason, there is nowhere in Lukács's work an examination of the specificity of art (despite the title of his last work on aesthetics) which satisfactorily justifies the politically progressive potential contained in it. Nor is there any attempt to provide a defence of his own restricted vision, which limits his analysis to traditionally accepted 'great' works.

Marcuse has even less hesitation in exempting the aesthetic from the distortions of capitalist society, and acclaiming art as the potential saviour for repressed and oppressed consciousness. In one of his earliest essays he began by criticising the 'affirmative' concept of culture, which by one means or another simply confirms and supports the existing unequal order; against this he counter-poses a 'negating' culture, which can take issue with society (Marcuse, 1968).

In *Eros and Civilisation* (Marcuse, 1969a) he follows Schiller in emphasising the nature of art as play, and develops this into a conception of art as the potential reconciliation between pleasure principle and reality principle (ibid., p. 156). In a society based on repression, art becomes or represents the possibility of freedom.

> Behind the aesthetic form lies the repressed harmony of sensuousness and reason – the eternal protest against the organization of life by the logic of domination, the critique of the performance principle. (ibid., p. 121)

At least until recently, art was thus opposition (p. 122), although there remained the danger that, as a result of the separation of the aesthetic, people could continue to separate their experience in art from their experience in the real world. Later, Marcuse was (briefly) to identify a real oppositional culture in the art and life-style of the student movement (Marcuse, 1969b).

Nowhere in any of these works is a non-idealist theory of aesthetic experience elaborated. To return to Schiller is even to ignore the historicist, Hegelian critique of the aesthetic categories, which Lukács himself adopted before his conversion to Marxism; for Marcuse, the aesthetic remains a universal, human category. In his last work, *The Aesthetic Dimension* (1978), he asserts even more boldly the autonomy of art from its social relations, presenting the essay as a critique of 'Marxist orthodoxy'. Despite its affirmative tendencies, he says, art remains a dissenting force (p. 8), speaking a 'language of radically different experience' (p. 40) and thus criticising the society of its origin. This argument he bases on the view that art is 'largely autonomous *vis-à-vis* the given social relations' (p. ix). The aesthetic dimension transcends the process of the production of art. But here we find even less of an attempt to explain how this can be possible. Instead, we find statements like the following:

> By virtue of its transhistorical, universal truths, art appeals to a consciousness which is not only that of a

particular class, but that of human beings as 'species beings', developing all their life-enhancing faculties. (p. 29)

The inner logic of the work of art terminates in the emergence of another reason, another sensibility, which defy the rationality and sensibility incorporated in the dominant social institutions. (p. 7)

As in the earlier writings, there is no careful analysis of the production of art as ideology which at the same time produces a critique of ideology in certain circumstances. In this latest essay there is not even a specification of the transformation of art under different regimes and in different social formations. On the question of aesthetic value, Marcuse's arguments are either circular or metaphysical:

I term those works 'authentic' or 'great' which fulfill aesthetic criteria previously defined as constitutive of 'authentic' or 'great' art. In defense, I would say that throughout the long history of art, and in spite of changes in taste, there is a standard which remains constant. (p. x)

Aesthetic formation proceeds under the law of the Beautiful, and the dialectic of affirmation and negation, consolation and sorrow is the dialectic of the Beautiful. (p. 62)

The autonomy of art, and the criteria for aesthetic judgement, are defended by simply asserting them. While recognising the ideological nature of art, as well as the relevance of the relations of production in which it is produced (for example, p. 15), Marcuse retreats from the challenge of elaborating a sociological aesthetics into the idealist categories of traditional aesthetics.

Finally, I turn to Althusser's exemption of art from sociological determinism. He solves the problem of whether art is purely ideological or whether it produces knowledge

by compromising and arguing that it is somewhere between the two (see Althusser, 1971b). It does not give us knowledge of the world, but makes us 'feel the reality of the ideology of that world' (ibid., p. 204). At the same time, art exercises an ideological effect, maintaining close relations with ideology, so that

> It is impossible to think the work of art, in its specifically aesthetic existence, without taking into account the privileged relation between it and ideology, i.e. *its direct and inevitable ideological effect*. (Althusser, 1971a, p. 220; emphasis in original)

But just as art does not provide knowledge, so it is not ideology either, for Althusser says: 'I do not rank real art among the ideologies' (1971b, p. 203). But this appears to be an attempt to demonstrate the specificity of art merely by stating that it lies between knowledge and ideology, while refusing to reduce it to either. This is both vague and unsatisfactory, in the context of a theory which insists on a clear distinction between science and ideology. It is hard to see what is intended by the assertion that art 'makes us see' ideology (1971b, p. 204), and in any case we may still ask whether this making us see is itself scientific or ideological. The implication of this for a theory of aesthetics is that, once again, the question of the specificity of art is both acknowledged and avoided, by the device of an arbitrary discovery of an intermediate category of thought or knowledge, in terms of which such specificity is defined, but which has no existence or argument outside the terms of this definition. The compromise is surprisingly woolly for the usually rigorous analysis of Althusser, as is his dependence on terms like 'seeing', 'perceiving' and 'feeling' (which he at least has the grace to put into inverted commas – 1971b, p. 205). An aside about aesthetic value does not make us any more confident that we can discover here a useful theory of art: 'Art (I mean authentic art, not works of an average or mediocre level) does not give us a knowledge' (ibid., p. 204). There is no recognition that the categories of

'authentic' or 'mediocre' art are in any way problematic. In general, Althusser's comments on art in these essays serve to confirm the view that the way to resolve the problem of the relationship between sociology and aesthetics cannot be simply to exempt art from the operations of social determination.

The fourth and last response to the sociological challenge is to accept it willingly, and to go on to develop a sociologically informed theory of the aesthetic. Materialist approaches to the specificity of art are examples of this work, for they take cognisance of the social production and reception of art, but also attempt to account for the particular nature of art. I shall be considering some of these writings in Chapter 5. In the meantime, I conclude this chapter by noting the failure of those other approaches which either collapse aesthetics into the social, or deny the relevance of sociology to the aesthetic, either by being unable to comprehend the sociological project, or by making an exception in the case of art. All of these, I have argued, are illegitimate strategies, and ones which get us no nearer the development of a sociological aesthetics.

One of the major difficulties which has emerged so far is the relationship between political or ideological value and what I have been continuing to call 'aesthetic value'. Although I have argued against the elision of the two, and the reduction of the latter to the former, the importance of understanding the ideological nature of art, shown by Eagleton, Hadjinicolaou and others, must be stressed. The problem then is to decide whether there are therefore two sorts of value in works of art – intrinsic, aesthetic value, and extrinsic, political value. If so, what is the relationship between the two? The simplest reply would be that the political value of a text or other work is totally irrelevant to its aesthetic merit. But this is to overlook the force of the argument which emphasises the inevitably ideological and historical position of all audiences, shown by hermeneutics, critical sociology and Marxism. Perhaps there is not the clear

distinction proposed by Bourdieu between two ways of looking at art, but rather the extrinsic or functional features of the 'aesthetic disposion' may be more carefully disguised and obscured. Certainly, it becomes difficult to see what kind of experience of art Becker can be identifying, if it is intended to be one which totally transcends the social and existential reality of the experiencer. As Jeremy Hawthorn has pointed out, 'No satisfactory way of drawing the distinction between aesthetic and non-aesthetic value has ever been found' (1973, p. 63). In the next chapter I shall consider the issue of the relationship between political and aesthetic value, in order to try to ascertain whether it is possible to identify such a distinction.

3

Political and Aesthetic Value

Quite apart from the reaction to the sociological critique of art, the notion of aesthetic value has been undergoing something of a crisis recently. It appears to have become more and more difficult to justify or defend any belief in 'objective standards' in the assessment of works of art. The traditional guardians of aesthetic quality have come under attack for biased policies and practices, even from within the arts. For example, the recent controversy about the buying policies of the Tate Gallery, in which the director of the gallery was accused, initially by David Hockney (1979), of favouring non-representational art has raised some important issues about the basis for assessment. (See also the reply by Norman Reid, 1979, and letters in the *Observer* of 18 March 1979.) The art critic Andrew Brighton (1977) has also criticised the Tate for presenting as official art what is ultimately the arbitrary choice of a select group of people. Similar criticisms have been mounted of the Museum of Modern Art in New York (see Wallach and Duncan, 1978). The avant-garde and its defenders in museums, publishing houses and elsewhere continue to come in for fierce critic-ism; the acquisition by the Tate of Carl André's bricks is simply the best-known, most notorious example of this (see for example, an article in the *Guardian* of 2 February 1980 about Alan Bowness, then recently appointed director of the Tate, which was headlined 'Guaranteed not to buy or drop bricks'). Recently the Royal College of Art has also been under attack from another direction, with the govern-ment's insistence that the College pay more attention to the

needs of industry (see articles in the *Guardian* of 14 November 1980, the *Observer* of 22 March 1981 and the *Times Higher Education Supplement* of 27 March 1981). The Arts Council of Great Britain has been criticised too in the pages of the press as well as in specialist journals for its conservatism, its elitism and closed practices, and its lack of accountability to the public (see Sutcliffe, 1981; Watts, 1980, 1981; Pearson, 1979; Craig, 1979).

Central to all these controversies is the question, 'What constitutes aesthetic value?' The fact that these debates have been raging suggests that the confidence with which this would, until recently, have been answered has been dissipated. It is no longer easy to hold the hitherto unquestioned view that we can recognise good art when we see it, or at least that those people who need to can do so, and that there is therefore no real problem about which paintings to buy, which authors to give bursaries, which theatre groups to support, and so on. For the policies and practices of the cultural elites have been exposed as exceedingly partial. Accepted establishment conceptions of 'quality' in the arts militate against the support of ethnic arts, for example, in which it is often the case that traditional criteria of assessment are quite inappropriate (see Khan, 1976, 1981). They also disallow consideration of popular art or works produced outside the mainstream of the literary or art worlds – for example, the autobiographies and other writings of working-class people which are published by the Federation of Worker Writers (see also Brighton and Morris, 1977). A recent study (McGuigan, 1981) of Arts Council grants to writers has shown that reliance on vague and uncritical notions of 'quality' and of 'serious writing' in fact disguises biased processes (of application, sponsorship and possibly assessment) which favour certain kinds of authors at the expense of others. The Arts Council is well aware of these criticisms, as are many of those in the cultural elites who produce, support, or present the arts. There is no lack of willingness to engage in debates about 'aesthetic quality', though the position of these people is often one of defensiveness or intransigence.

A conference organised in 1980 by the journal, *New Universities Quarterly* (the proceedings of which are now published as volume 35, no. 1, Winter 1980/1) took as its theme 'Excellence and standards in the arts'. The papers represent a variety of points of view, ranging from criticism of the avant-garde through the defence of objective standards in evaluation to the criticism of cliques and coteries in the world of the arts. But although some writers take issue with the particular choices and preferences of the Arts Council of Great Britain and of the dominant museums, and although they present a variety of analytical positions from which one might establish standards, what they have in common is the relatively unproblematic belief that such standards do exist or can be established.

Sir Roy Shaw, Secretary-General of the Arts Council, is most explicit about this.

> The Arts Council is essentially in the business of making value judgements, and ... doubts about the possibility of making objective value judgements can stultify the work of the council, especially of its Advisory Panels and Committees, not to mention its officers. (Shaw, 1980/1, p. 33)

Nor is this merely a pragmatic faith in objectivity, for when he goes on to discuss challenges to the notion of 'excellence' he finds them ill-founded.

> Of course, in practice, value judgements often tend to be tainted with subjectivity, but the point of a Panel is through discussion to move beyond subjective limitations and to arrive at a more objective collective judgement. (ibid., p. 35)

The ability to make such value judgements, he goes on, comes from 'a combination of native ability, education, training and experience' (ibid., p. 36).

Other contributors also reassert traditional assumptions about art, in similarly traditional and uncritical vocabulary.

Dickens appears to be the hero of the conference (see Hoggart, 1970/1, pp. 23–4; Holbrook, 1980/1, pp. 89–93) against whom the excesses of contemporary or experimental literature are measured. But throughout, the defence of 'standards' is absent, at least in the necessary analytic terms which would take issue with the specifically aesthetic criteria employed (rather than returning to discredited notions like 'humanity struggling to understand itself . . . in pursuit of the truth': Holbrook, 1980/1, p. 93), and which would at the same time acknowledge the social production, reception *and* evaluation of art, and take seriously the possible relevance of these contingencies.

The feminist critique of art history and criticism has also been deflected by the mainstream of these disciplines, and by the establishment of the arts. Yet, as Griselda Pollock and others have shown, gender considerations do intervene in the search for 'excellence'. This is very well illustrated by the well-known case of the painting by David (*Charlotte du Val d'Ognes*, c.1800, in the Metropolitan Museum, New York) which, when it turned out to have been painted by a woman, Constance-Marie Charpentier, plummeted both in value and in critical estimation. (See Hess, 1973, p. 45; on the reassessment of the work after this discovery, see Greer, 1979, p. 142; Parker and Pollock, 1981, p. 106.) Women's art is generally assessed, implicitly and perhaps unconsciously, in different terms from works by men (see Pollock, 1979). So where, on the one hand, with community arts, ethnic arts and working-class literature, the guardians of aesthetic standards insist that everything must be evaluated by the same universal criteria (see, for example, Hoggart, 1980/1, pp. 27–8, on the taxi-driver writer, who 'needed to be introduced to the disciplines of the draft'), on the other hand we find that in the case of women's, and particularly feminist, art, differential criteria are for some reason deployed.

So the defence of 'objective standards' by those whose job it is to maintain them provides little reassurance that they can either be defined or be shown to be objective. The crisis in the arts, rather than simply requiring a firm hand in

the face of the invasion by 'trendy anti-art experimentalists' (Daley, 1980/1, p. 60) and others, itself demonstrates the complex interrelations between art and politics. For if 'excellence' turns out to mean nothing more than the preservation of the received heritage of art and literature, and finding terms in which to commend its already accepted 'great works', then the difference of opinion between those institutionally placed to safeguard this heritage and others who may wish to challenge it may be (as Bourdieu maintains) nothing more than the class struggle fought in the area of cultural capital. But those who wish to argue the greatness of Dickens need to do so in the full, self-reflexive knowledge of the way in which Dickens was constructed in historical, social, class and gender conditions, and of the equivalent construction both of themselves as critics and of the critical tradition which has produced and maintained Dickens as a great writer. It remains to be seen whether this greatness can consist in anything *other* than the political and ideological preferences of those involved.

The problem of value is a long-standing one for the social sciences in general. The issues of value-freedom and of the fact/value distinction go back at least to Weber, and continue to inform positivist, anti-positivist, realist, Marxist and other discussions of the nature of social science. The critique of positivist methodology and theory, both by the interpretive sociologies like phenomenology, ethnomethodology and hermeneutics, and by the critical sociologies like Marxism and the sociology of knowledge, appears to have rejected definitively the notion that we can always or unproblematically separate facts from values, or that we can know something apart from our own perspective and interests in that knowledge. Knowledge is produced in theory and concepts, and is theory-dependent in the sense that it is inconceivable that we could 'know' something like a social fact without this knowledge being formulated, and thus experienced, through the concepts which make it accessible. Theories direct our attention into certain avenues and close off others. Moreover, knowledge is produced in

social groups, which serve to orientate the scientist, and also to confirm and validate his or her findings; the progress of a science, as recent work in the sociology of the natural sciences also shows (see Mulkay, 1979), is the result of social processes and relatively arbitrary agreements or decisions. Weber's notion of 'value-relevance' is important, for it recognises that research is in the first instance motivated by particular interests and values. But it seems that his associated concept of 'value-freedom' cannot be upheld, for there is no stage at which values may be eliminated.

Values are, first of all, implicated in the subject-matter of a social science, as Richard Bernstein points out.

> What is taken for granted as the starting point for empirical research, as the realm of 'brute fact' that presumably grounds...research, is itself the product of complex processes of interpretation which have historical origins. (Bernstein, 1978, p. 230)

Secondly, values reside in the interpretation of the material itself – in this case, the values of the researcher. Hermeneutic theory, following Dilthey and Gadamer in particular, shows that all knowledge in history and social science is reinterpretation from the point of view of the interpreter, for the task of identifying totally with one's subject and eliminating one's own existential reality is an impossible one.

The work of the critical theorists has been influential in sociology in developing the critique of knowledge and objectivity. In his inaugural lecture at Frankfurt in 1965, entitled 'Knowledge and interest', Jürgen Habermas systematically explored the relationship between different types of knowledge and their motivating interests (see Habermas, 1970a). Like Gadamer, he resists the philosophical inheritance of Enlightenment thought, and particularly its rationalist and later positivist manifestations, with its false separation of knowledge from practical concern. In this, he agrees with phenomenological and hermeneutic theories, which also reject false objectivism, and concern

themselves with the practical aspects of knowledge. However, he takes the argument further, turning it against these interpretive approaches, and argues that critical social science will also be able to demonstrate the ideological nature of these practical concerns, for on the whole the interpretive sciences are not reflexive, and are not equipped to perceive their own construction in social and ideological factors. Just as positivist or technical knowledge has a constitutive interest in the demands of *work*, interpretation is motivated by an interest in, and need for, practical communication, particularly in *language*. Critical theory is not exempt from interest-determination, but is grounded in an interest in *emancipation* from the system of authority. For all forms of knowledge originate in relations of domination and repression, though these relations are heavily disguised or concealed in the objectivism of both empiricism and interpretivism.

It is for this reason that Habermas and Marcuse (another writer in the Frankfurt school tradition) have always reserved their strongest condemnation for the claims and illusions of the natural sciences, which, presenting themselves as the epitome of 'objective' knowledge and detached rationality, in fact operate in the interests of the status quo and of the dominant groups in society. Moreover, they are, in their naive assumption of value-freedom, available for manipulation for the most irrational ends; as both Marcuse and Habermas point out, whatever we think of the methods of natural science, its mobilisation for particular ends (making nuclear weapons, for example) can never be the outcome of scientific processes of deliberation. Self-reflexivity on the part of natural science, then, would render it less vulnerable to such manipulation, by alerting its practitioners to the institutional and interest-bound features of science itself. As Habermas (1970a, p. 53) says, 'A delusive philosophy of history is the reverse side of blind decisionism; a bureaucratically ordained partiality goes only too well with a neutrality of value, contemplatively misunderstood.'

If all knowledge is founded in particular interests, which, far from obliterating themselves in scientific thought,

remain to permeate all knowledge, what are the implications for 'objectivity'? Does the critique of knowledge and of ideology render all knowledge partial, and result in philosophical and epistemological relativism? I think it is worthwhile, before returning to the problems of objectivity in aesthetics, to consider the current state of this debate in sociological theory generally. We have seen that, according to Habermas and others, knowledge can never be 'objective' in the sense that it is always perspectival or produced in specific contingent institutional contexts (though Habermas does in fact retain a notion of 'truth'). The question is whether it can nevertheless be 'objective' in the sense of transcending its source, and approximating to 'truth'.

Russell Keat, in a recent critical study of Habermas which to some extent reinstates the notion of value-freedom (Keat, 1981, p. 36 in particular), argues that despite the existence of normative elements in social science, its statements are still amenable to criteria of validity, and in this sense value-free. He insists on the logical independence of scientific criteria of validity from such normative elements (ibid., p. 42) and argues that the descriptive or explanatory claims of science can therefore be evaluated: 'It is possible to assess these claims by reference to scientific criteria of validity that are logically independent of any specific moral or political commitments' (ibid., p. 39). He emphatically rejects Habermas's conclusions, that the truth or falsity of statements in social science is a function of their emancipatory power or success, or of their acceptance by those whom they concern. (Habermas uses, and Keat follows, the model of psychotherapy as emancipatory social science, and so the discussion is about the patient's acceptance of an interpretation or of the successful outcome of the therapeutic treatment, as a model of the social actor's recognition of the power relations underlying communication, and the overthrow of those power relations.) Keat quite rightly points to a number of illogicalities and weaknesses in this new criterion for objectivity, not least the danger that if success is the touchstone of validity, then potentially any social theory (for example, a fascist one) may turn out to be 'true' (Keat,

1981, p. 155). Certainly it is the case that failure to convince the patient/social actor does not necessarily mean wrong theory, for as Habermas himself points out there are innumerable resistances from the subject to accepting the truth. Critical theory may avoid the dangers of fascism as truth by referring back to the necessary conditions of truth as consisting in non-repressed communication in relations of equality. But this has itself been a notorious problem for Habermas and his followers; from what vantage-point are we to assess some (potential) social relations as 'equal'?

Giddens (1977a, p. 161) has argued that Habermas's theory of truth is in fact not far removed from Gadamer's hermeneutics which produce a consensus theory of truth, (see also Held, 1980, pp. 389–98). But Gadamer had already redefined objectivity in explicitly relativistic terms, as the (changeable) product of the hermeneutic process (Gadamer, 1975, p. 237). As Keat argues, Habermas's concepts of the 'ideal-speech situation' (of undistorted communication) and of 'rationality' of discourse do not successfully substitute new criteria of validity or objectivity.

> Habermas's view that there are distinctive criteria of validity for critical social theory rests partly on the claim that the truth of such a theory is tied to its successful translation into practice. I have criticized this, and proposed instead that there are significant gaps between the truth of explanatory theories, the success of techniques, and the theoretical rationale for such techniques. (Keat, 1981, p. 200)

For Keat, there are no such distinctive criteria of validity, apart from those based on the science/value distinction.

I think Keat is right to argue that critical theory does not provide us with a new theory of truth. To accept Habermas's conception of truth, we need first to accept his idea of the nature of the rational society, for this idea cannot be supported with empirical evidence or *a priori* argument. More serious is the fact that this theory throws very little light on

the problem of the truth-content of contemporary science; will all the statements of science become transformed into 'true' ones in the rational society, and are they (necessarily) false now? Habermas would no doubt object to Keat that the very criteria of objectivity which he adopts are part of the scientistic ideology, and thus partial and ideological. But if we accept the truth of the social determination of all knowledge, are we thereby committed to a relativist notion of truth?

Mary Hesse (1974), influenced by many of the arguments of Habermas, settles for a weak notion of objectivity which is something of a compromise. She argues that even the natural sciences are subject to hermeneutic processes, and hence to the non-objective implications of any interpretation. The 'post-empiricist' account of natural science demonstrates that data are always theory-laden, that the language of theoretical science is metaphorical and inexact, and that the logic of science is 'circular interpretation, reinterpretation, and self-correction of data in terms of theory, theory in terms of data' (p. 281). Such a hermeneutic theory of science raises the same problems for truth as similar theories of social science. Hesse, like Habermas, sees the guarantee of objectivity in dialogue for the human sciences, and suggests it may also be appropriate for the natural sciences, to the extent that they too are hermeneutic. However, she does not extend her discussion to the point of identifying any ultimate truth in future equal social relations. Here we have again a consensus theory of truth, though without this higher promise such truth is therefore relative. In the philosophy of science too there seems to be a loss of faith in non-relativist criteria of validity.

It is difficult to see how the criteria of truth of any science can be guaranteed outside the terms of reference of that science. Tony Bennett discusses this with regard to Althusser, who distinguishes science from ideology. Ideology is defined in so far as it departs from the knowledge proposed by a particular science. As Bennett argues, however, this same logic must then also be applied to Althusser's

own 'science', which becomes ideological from the point of view of another science. For as Althusser himself has said, following Spinoza, a science is the measure of its own truth value, and of what is false in relation to it (see Bennett, 1979, p. 139; see also page 17 above). I do not want to take any further the question of scientific validity, nor do I claim that those arguments I have been discussing are necessarily exhaustive of the positions which may be taken on this issue. From the point of view of the sociology of art, we simply need to observe the problematic nature of all claims to objectivity. Although this arises in aesthetics in a very particular way, it is not a problem unique to that discourse. I proceed on the assumptions, then, that all knowledge is interest-linked and perspectival (whatever the implications of that for the question of 'truth'); that different discourses have their own internal criteria of validity, independent of the genesis of knowledge, although these criteria can have no relevance outside that discourse; that it is possible to propose a definition of 'objectivity' which depends on some higher truth arising in the interplay of perspectives – the dialogic notion defended by Gadamer and Hesse; and that, so far, attempts to produce an ultimate notion of objectivity or truth (as in Habermas's writings about the ideal-speech situation) have been unsuccessful. I shall now go on to consider the ways in which these arguments are also relevant to aesthetics, and whether value in art is illuminated by the discussion of value in sociological theory.

My first point is that in one way it is necessary to reverse the terms in looking at aesthetic value: for if, so far, I have been concerned with the extent to which facts are value-laden, the question about aesthetics is rather the extent to which values are 'fact-laden'. In other words, the central issue with regard to aesthetic evaluation is whether or not this is necessarily based on (or, at the extreme, reducible to) extrinsic facts. Giddens, in an essay on Weber and values, has reiterated the now-familiar argument that 'evaluative appraisal always involves factual elements' (1977b, p. 95). As he points out, in the case of both ethics and aesthetics,

we differentiate personal preference from informed evalua-
tion, and are generally prepared to defend the latter ration-
ally, in terms of empirical knowledge and statements. In an
aesthetic evaluation, this might take the form of citing
colour relationships, balance of form, structure of narra-
tive, and so on, as evidence for the judgement, though of
course at each point both the assessment of the evidence
and its basis for an overall evaluation may be contested, or
alternative empirical criteria proposed. The point is that
evaluation is inseparable from empirical and factual aspects
of its object. Values cannot be 'fact-free'.

But the next step is to observe that these very facts them-
selves both constitute and comprise values. The reasons we
may give for approving a work of art, though based on
empirical information about that work (its colours, use of
language, musical harmonies, sculptural line) are value-
laden in their very choice of such empirical criteria, in the
language in which they are formulated and in the numerous
extrinsic (biographical, sociological, political) factors
which necessarily intrude into those reasons. This is not to
beg the question by assuming that all such judgements are
merely ideological or political, for I think it is already clear
that this is not the case. It is to suggest that they are, among
other things, ideological. For, as we have seen, all evalua-
tions involve a certain factual defence; and facts are always
value-laden. Aesthetic values, then, necessarily involve
other, extra-aesthetic values.

It might be argued that it is misleading to move so directly
from Habermas and the critique of knowledge to aesthetics.
Art and aesthetics do not deal in the kinds of knowledge
which can be 'true' or 'false'. So the concept of 'objectivity'
is in fact ambiguous. It sometimes means 'true' (Habermas's
critique of instrumental reason is a critique of a concept of
truth), but it can also mean value-free, or perhaps non-
subjective (not necessarily the same thing), as when we
claim that our aesthetic standards are 'objective'. Are artis-
tic knowledge and scientific knowledge similar in respects
relevant to this critique of knowledge? If not, it may be that
aesthetic knowledge (the experience of art, whether this be

cognitive, emotive, or something else) and its associated aesthetic judgements are not appropriately analysed by the critical theory of knowledge, for although aesthetic judgements may claim the status of 'truth', aesthetic experiences generally do not.

In the framework of the sociology of knowledge, art is 'knowledge' just as much as science, for the term is wide enough to include common-sense knowledge, scientific knowledge, religion, ethics, philosophy and aesthetics. Nevertheless, for many years it was the case that these different types of knowledge were treated differently by the sociology of knowledge. Work in the sociology of science, while exploring the institutions and social conditions in which science is produced, was not thought to affect the validity of scientific theories. It is only fairly recently that some sociologists and philosophers of science have reached more radically relativist conclusions which throw into question the claims of science to objectivity (truth). In the case of the sociology of religion, it used to be the case that the operation was assumed to be one of de-bunking; demonstrating the social origins of religious thought was thought to be enough to prove its falsity. Now, moving in the opposite direction from the sociologists of science, sociologists of religion tend to be circumspect, allowing that sociology and religion are different discourses; that the criteria for truth of the latter may be beyond the reach of the former (and might, for example, still involve a metaphysical argument for the existence of a supernatural being) or that the rules for ascertaining truth are simply internal to each discourse. Religion thus acquires a relative autonomy, while the total autonomy of science is brought into question (see Bellah, 1970).

The sociology of art has been unlike either of these other sociologies in suspending entirely the question of truth. Because art was not thought to be concerned with strictly cognitive ideas, the truth-content of art did not seem to be an issue. For example, Talcott Parsons explicitly segregates art from belief systems, categorising the aesthetic as that which operates in the sphere of 'expressive symbols' (see

Parsons, 1951, ch. IX). Writers who allow that art may combine expressive with cognitive ideas nevertheless do not consider that sociology creates any problems for the status of those cognitive ideas.

James H. Barnett, in an early article published in 1959 which outlines the field of a sociology of art and surveys its intellectual roots, begins with such a definition of art:

> Art embodies and expresses a wide range of human experience, emotions, beliefs and ideas in esthetic forms which appeal to the senses and evoke emotional and intellectual responses in the human mind. (Barnett, 1959, p. 197)

He argues that the sociology of art should investigate all the processes in which art is produced, looking at artists, institutions, audiences and works of art themselves. But far from feeling that such analyses may cast doubt either on the cognitive content *of* art or on the objectivity of judgements *about* art, he says that the sociologist must continue to bow to the superior knowledge of the art specialists.

> In studying the arts, the sociologist confronts one difficult problem that can be solved only with the sympathetic collaboration of the art historian and critic. This is the problem of identifying the works of 'serious' art that are worthy of study and of determining their place in the historical development of the particular art form. Without assistance from those who have technical knowledge of the arts, the sociologist will usually be unable to discriminate between matters of style, imagery, subject matter, and the like that reflect important social and cultural influences and those that express merely the dominant esthetic conventions of an art at a specific time. (ibid., p. 211)

The cognitive element, even for those who consider it an integral part of works of art, is played down. Art is not assessed in terms of its portrayal of correct ideas.

More recently, developments in the philosophy of science and in different branches of the sociology of knowledge lead us to conclude that there is little to distinguish the various discourses. Each discipline – science, theology, aesthetics – and each mode of knowing – empirical, technical, religious, artistic – has its own criteria for valid knowledge, and its own peculiar discursive style. Each of these is open to investigation by sociological techniques. No one is invalidated more than any other. But in each the formulation of the problems, the processes of their resolution and the terms in which the resulting knowledge is expressed are all bound up with the social and political standpoints of their practitioners.

I conclude this chapter with a discussion of the relationship between art and politics, which, taking into account the foregoing comments on the limits to objectivity and the invariably ideological aspect of aesthetic judgement, examines the possibility of a non-reductionist theory of art. I want to suggest that the recognition that art is always political, in the sense indicated, does not mean that art is *only* political, or that, as Hadjinicolaou argues, aesthetic evaluation is nothing but the concurrence of two ideologies.

Art may, of course, be explicitly and intentionally political. Artists and writers have often put their work at the service of political revolutions (and also of political reaction) and at the same time developed a new aesthetic in accordance with their ideological and political critique both of society and of dominant but outmoded forms and theories of art (see Ehrmann, 1970; Gray, 1971; Rühle, 1969, pt I; Scharf, 1972). Other writers have examined the ways in which art may also play a political role in times of stability, exploring the means by which innovation in art may produce transformation of political consciousness (see, for example, Brecht, 1964; Benjamin, 1973b; Lenin, 1970). In these cases, art is mobilised for political ends, though this does not mean that art becomes merely agitprop. This occurs only when all considerations of form, composition, and so on, are totally subordinated to considerations of propaganda. Benjamin

(1973a) has argued that it is impossible for a work to be politically correct unless it is also aesthetically correct:

> A work which exhibits the right tendency must, of necessity, show every other quality as well . . . The tendency of a work of literature can be politically correct only if it is also correct in the literary sense. (p. 86).

Others would prefer to argue that the literary merit and the political merit of a work of art are judged independently, but at least that political merit need not be at the expense of literary merit. For all these writers and artists, however, the political role of art is paramount.

Art is also often political to the extent that it is concerned with political themes. David's *The Death of Marat*, Solzhenitsyn's *The First Circle* and Britten's 'War Requiem' are examples of this (see also Howe, 1970). In addition I would include in this second category novels which deal with politics in the wider sense—for example, sexual politics—and works which are ostensibly about non-political matters but which were produced with political intent, perhaps using the devices of historical displacement (as in some genre painting) or allegory (as in Kafka's writing). Unlike those works in the first category, the intention behind these works may not be to mobilise audiences or to intervene in political events. The depiction of politics, too, is less often associated with an intention to develop a new aesthetic (or to transform the practice of art). But such works cannot properly be understood without a knowledge of the political inspiration and reference involved.

More relevant for the sociology of art is the fact that art which is neither explicitly nor allegorically concerned with politics is none the less political. For example, a painting with apparently 'innocent' subject-matter can be decoded to identify its political and ideological position. Hadjinicolaou detects a criticial visual ideology in the pink bow of Goya's *Marquesa de la Solana* (1978a, p. 174); Lovell (1978) has shown the political ideology which underlies the novels of Jane Austen; and John Berger has argued that the

tradition of oil painting has been permeated by a concern for, and emphasis on, property (see Berger, 1972, ch. 5). Informing all these studies is the sociological perception that all thought, and *a fortiori* its representation in art, is ideological.

But it is also important to recognise that works will often have more than one set of political meanings. As semiotics and hermeneutics have conclusively shown, cultural products admit of multiple 'readings'. Where political doctrine is not the intention of the artistic producer, it is more likely that the implicit meanings of the work will be found to be complex and even contradictory ones, reflecting both the contradictory nature of consciousness and the relatively autonomous operation of the artistic system of representation. Thus, works generally taken to be conformist or supportive of the status quo have suddenly been found to offer new, subversive meanings (see, for example, Marxist-Feminist Literature Collective, 1978; Berger, 1972, pp. 57–61, on the nude; and Eagleton, 1981, pp. 15–16, on Richardson). A potentially critical aesthetic-political ideology does not necessarily produce a critical reading, for this depends on the position of the reader. In any case, these arguments suggests that it is never a simple matter to identify *the* political ideology of a work, for most works apart from the most banal will not be reducible to a single, unified set of values. The central point is still that all works of art, being produced in political-historical moments by particular, located people using socially established forms of representation cannot fail to be, however, implicitly, about politics. And, as Hadjinicolaou's discussion of the paintings of David shows, the politics of art may be conservative as well as critical (1978a, pp. 157–62).

A variant of this argument is the view that a political critique can be produced in the text, not so much by its inherent political opposition, as by the subversion of the literary or artistic form itself. Hadjinicolaou's argument about the painting by Goya, already referred to (page 63 above), depends on the importance of the use of colour. Other work along these lines has been influenced by the

writings of Julia Kristeva on modernism and of Lacan (see, for example, MacCabe, 1978).

There is a crucial sense, then, in which all art is political. Does this mean that art is reducible to its political-ideological features? Allowing that art does not simply reflect ideology but reproduces it through forms of representation, some writers nevertheless seem to believe that there is such an identity, for they refuse to proceed to discuss the possibility of any non-political aspects of art. Tony Bennett, bemoaning the fact that Marxist aesthetics has up to now failed to disentangle itself from traditional aesthetics, hopes that the re-examination of the work of the Russian Formalists will provide 'a new set of concerns for Marxist criticism, a new concept of "literature", which will shift it from the terrain of aesthetics to that of politics where it belongs' (Bennett, 1979, p. 3).

We have seen that it is certainly true that aesthetics and politics are inseparable, for the social history and sociology of art demonstrate the political nature of all cultural products. However, it does not follow that aesthetics and politics are the same thing, nor that art is merely politics represented in symbolic form. Neither, as far as aesthetic evaluation is concerned, does it mean that aesthetic judgement follows from political assessment. For example, it may well be that a work preserves its status as a 'great work of literature' through a number of changes of interpretation as to its political intent or implications. Perhaps this could be explained in terms of the inertia of bourgeois categories of evaluation (and I think there would be some truth in this) but it does not help us to understand what is involved in the assessment or enjoyment of the text.

I maintain that attempts to incorporate aesthetic value into political value or to explain it in political terms provide very limited accounts of aesthetics. Benjamin, as indicated earlier (pages 62–3 above), argued that a work could not be politically correct without being at the same time aesthetically 'correct'. In a recent article, Jennifer Todd has argued that 'in some historical circumstances criteria of aesthetic evaluation coincide with criteria of political worth, so that

an aesthetic motivation exists to make political art' (Todd, 1981, p. 16). She suggests that, in itself, the aesthetic imperative to transform the relations of artistic production in order to facilitate the progress of art involves political and social progress, for the traditional relationship between producer and consumer and the class-based hierarchy of the art world are thereby challenged. But at most, this shows that there is sometimes an aesthetic motive to make political art. It does not provide a general political aesthetics; nor does it demonstrate that all 'good' art is good because of its political correctness, or indeed claim to do so. Despite Benjamin's assertion, the coincidence of aesthetic and political value has not been proved.

The aesthetic evaluation of works of art may often be based on implicit political values. I have argued in this chapter that all knowledge, including evaluative knowledge, is political in the wider sense. Political values may intrude into aesthetic judgements in two ways: by supporting or attacking vested interests in the persistence and dominance of particular art forms (which is one of the issues involved in the present crisis of values in the Arts Council and other bodies discussed at the beginning of this chapter); and by bringing political values to bear in the actual assessment of particular works (as has been argued, for example, against mainstream literary criticism and its work in the interests of a privileged class – see Eagleton, 1978b). But there is clearly more to say about what is involved in aesthetic assessment. There is the problem of discerning the 'politics' of classical music (and I do not mean examining the social and political structures in which it is developed, but rather discovering its consequent political or ideological content or import). There is a similar difficulty with non-figurative art, though Peter Fuller (1980b, pt I) has attempted a critical reading of abstract art.

Political aesthetics also has to find some way of explaining the persistence of judgements whose social and political conditions of origin are superseded, as well as to give an account of fluctuating interpretations and multiple readings. For

example, the presentation of Courbet's work in a major London exhibition totally ignored the 'radical', and influential, interpretation of this painter by T. J. Clark (see Arts Council of Great Britain, 1978, and Clark, 1973). In general, the explanation of aesthetic value in terms of political values is at best only partial. In the next chapter, by looking at some theories about the nature of aesthetic experience, I shall re-examine the question of the surplus of meaning over the political in art, in order to determine whether there are, as Keat claims in the case of science (1971, p. 39), criteria of validity or judgement which are independent of moral or political commitments. The merger of political and aesthetic criteria in practice in very many instances should not deter us from the search for the specifically aesthetic grounds on which works of art are also assessed.

4

The Nature of the Aesthetic

My argument in this chapter is that there has been a significant degree of convergence between certain philosophical theories of art and certain sociological theories, in that on the one hand there is a growing acknowledgement of the essentially social nature of all aesthetic experience, while on the other hand increasing emphasis is placed on the specificity of that experience. I hope that a discussion of these developments, particularly in the case of the philosophy of art, will open the way for an investigation of the particular nature of that specificity, and how it can be comprehended within a sociological aesthetics.

Aesthetic theory deals with a number of different kinds of question, which, although they are clearly related to one another, are also of a different order and raise different problems. (See Osborne, 1972, introduction; Hospers, 1969, p. 2.) Among these questions are: (i) what is art? (ii) what is the nature of aesthetic experience? (iii) what is (the nature of) beauty? (iv) what are the criteria for aesthetic judgement? (v) what is aesthetic value or merit? Some philosophers of art link two or more of these questions. For example, Roger Scruton (1974) has argued that aesthetic judgement and aesthetic appreciation cannot be described independently, for the analysis of judgement is itself based on the analysis of what is involved in aesthetic experience. Nelson Goodman, on the other hand, maintains that questions of aesthetic value are both distinct from questions of aesthetic features and secondary to them (Goodman, 1976,

pp. 255, 261–2). Gadamer's discussion of aesthetics and hermeneutics appears to elide the two issues, perceiving both the nature of art and the characteristics of good art as consisting in 'surprise' (see Gadamer, 1976, p. 101). And Hospers suggests that we recast the question 'What is beauty?' to read 'What is aesthetic value?' on the grounds that the word 'beauty' is too narrow (Hospers, 1969, p. 11). As he says, one does not speak of a beautiful drama or novel, in the way one speaks of a beautiful painting. But I would prefer to leave them as two separate questions for, as with any of these elisions, the relationship between different aspects of 'the aesthetic' depends entirely on the aesthetic theory which is adopted. Against Hospers, we could say that even an ugly painting may have aesthetic merit. So it is not just a question of the term being too narrow, and being replaced with another term, more or less equivalent but more extensive; the two are different terms entirely, linked only by the fact, which may be accidental (again depending on one's theory of art), that beauty and aesthetic merit have tended to coincide in the history of criticism.

However, I think we can say that criteria of evaluation are always necessarily related to and dependent on a theory of the nature of art or the aesthetic. We need first to know what sort of thing art does before we can assess whether certain works do it well. Here I agree with Goodman (1976, p. 259), who says 'Aesthetic merit is such excellence in any symbolic functioning that, by its particular constellation of attributes, qualifies as aesthetic' (although I do not necessarily agree with his view of what such symbolic functioning consists in, as far as aesthetics is concerned). Therefore in this discussion I shall concentrate primarily on the question of what is involved in 'qualifying as aesthetic', which I take to be prior to the question of merit.

Philosophers of art have long recognised the problems associated with attempting to identify the aesthetic in terms of properties of particular objects. Many of these problems are discussed by Wollheim in his book *Art and its Objects* (1980). At first sight, it appears to be a sensible strategy to try to discover the nature of art and the aesthetic by considering

those instances in which it occurs (or, which for some philosophers of art amounts to the same thing, in which we use the vocabulary of 'art', 'aesthetic', and so on, appropriately). This involves the investigation of the variety of things which we call 'art' (for instance, paintings, dance, literature, music, sculpture, architecture) in order to isolate their common 'aesthetic' feature or features. It ought to be the case that if we could formulate our conception of what a novel and a painting have in common we have gone some way towards identifying 'the aesthetic'. But as Wollheim clearly shows, it is not possible to approach art simply through the observation of particular objects. For one thing, not all works of art *are* physical objects. The performance arts do not consist in single physical objects, but rather in the particular performance and/or in the work itself (which is not an object at all), and Wollheim refers to these as *tokens* and *types* respectively (Wollheim, 1980, pp. 74–9). The same applies to a novel, which, although it is not a performance art like an opera, is not thought to consist, say, in the original manuscript of the author (though this might, for other reasons, be treasured or exhibited in the British Museum) or in the first edition or indeed in any one particular physical object. The type is the original 'piece of human invention' (ibid., p. 78), and from this tokens (particular examples or performances) are generated. Wollheim does not in fact claim to have disproved the 'physical object' hypothesis of art, although he systematically raises many of the difficulties associated with such an analysis. Other philosophers have proposed a variant of the 'physical object' hypothesis which focuses on the particular *properties* of works of art; in this case, works of art are not necessarily *physical* objects. An earlier, and influential, theory of this kind is Clive Bell's notion of art as 'significant form' (Bell, 1958). However, Bell's work claimed to be a theory of *visual* art and its limitations when transferred to music or literature are apparent when we read what Bell intends by the term.

What quality is common to Sta. Sophia and the windows

at Chartres, Mexican sculpture, a Persian bowl, Chinese carpets, Giotto's frescoes at Padua, and the masterpieces of Poussin, Piero della Francesca, and Cézanne? Only one answer seems possible – significant form. In each, lines and colours combined in a particular way, certain forms and relations of forms, stir our aesthetic emotions. These relations and combinations of lines and colours, these aesthetically moving forms, I call 'Significant Form'; and 'Significant Form' is the one quality common to all works of visual art. (Bell, 1958, pp. 17–18)

Two other things to note about this statement are, first, that it avoids the question of whether what is significant for one person, or culture, may not be so for another; and secondly, that aesthetic properties appear to be inseparable from audiences' reactions, since Bell describes significant form as 'stirring our aesthetic emotions'. So the problem of definition is displaced, for now we need an account of 'aesthetic emotions'.

In contemporary aesthetics, some writers have continued to propound theories of art which depend on the analysis of the properties of works of art (see, for example, Hungerland, 1972). For some, the essentially aesthetic aspects of works are emotive (Langer, 1962); for some, expressive (Elliott, 1972); for some, imaginative (Scruton, 1974; see also Collingwood, 1963); and for some, cognitive (Goodman, 1976; Hess, 1975; also Scruton, 1974, p. 4). In some cases, these features are related more to the mental activities of the artist (Goodman, 1976, p. 258), in others to those of the audience or viewer (Scruton, 1974), and occasionally to both (for example, Morawski, 1974, p. 115). However, since the general points which I want to make apply to all these variants of the theory of art, I do not propose to compare and assess them. As other writers have shown, most of them run into some difficulty or other, whether this be in maintaining the essentially cognitive nature of art or in equating 'art' with a range of objects or in defining the aesthetic in terms of a particular kind of experience (see Hospers, 1969; Osborne, 1972; Wollheim, 1980). Aesthetic

theories centre variously on physical objects, perceptual properties of works and mental states of artists or audiences, and they continue to be strongly counter-posed to one another by their current proponents. In their traditional, or even their up-dated, forms all such theories are handicapped to the extent that they isolate the aesthetic from other areas of social life; for the inevitable anomalies and difficult cases which arise for a theory of art (for instance, 'Is film art?') can only be dealt with in the context of a wider understanding (see Wollheim, 1980, p. 152). Scruton argues that the very vocabulary of aesthetics is artificially and detrimentally separated from related terms outside aesthetics.

> The theory of aesthetic perception fails – as do many other theories – by creating too sharp a divorce between the aesthetic and the non-aesthetic use of terms, so that, ultimately, it leaves itself with no explanation of the meaning of aesthetic judgements. (Scruton, 1974, pp. 40–1)

So if a work of art is described as 'sad', this must be a judgement by the same criteria as those governing the use of the word in normal, non-aesthetic conversation (ibid., p. 42). More important (as Scruton, Wollheim, 1970, Gombrich, 1960, and Morawski, 1974, have recognised) the nature of the aesthetic experience, and the existence and identification of works of art themselves, are determined and affected by extra-aesthetic factors. As Morawski comments, with regard to his inquiry into the criteria of aesthetic valuation,

> What we need to learn is how and to what extent the traits of the 'aesthetic object' and the 'aesthetic experience' can be clarified by discerning these phenomena historically, and, above all, as newly emergent phenomena still closely integrated with other heterogeneous phenomena. (1974, p. 45)

I want to pursue this line of argument, a direction taken by a few philosophers of art only recently, by considering

two developments in aesthetic theory which help to resolve some of the difficulties for traditional analytic approaches and also lead inevitably to a more sociological aesthetics. These are the notion of an 'aesthetic attitude', and what might be called the 'institutional theory of art'.

Theories of the aesthetic attitude are, in fact, as old as aesthetics itself, going back to Kant's *Critique of Judgement*, and continuing to influence one strand of the philosophy of art through neo-Kantian and, later, phenomenological approaches (see Podro, 1972, on Kant's aesthetics and its influence on some later writers). The idea that there is a peculiarly aesthetic attitude offers a solution to some of the more perplexing issues which have exercised philosophers, such as whether or not we can consider the enjoyment of a sunset or landscape to be an 'aesthetic' experience, and whether Duchamp's ready-mades are 'art'; for the answer is that we may look at *anything* in the aesthetic attitude. 'Art' is either that which is produced in this attitude or that which is experienced thus. The case of ethnic objects which may have been entirely *non*-aesthetic (that is, functional, symbolic, religious), plundered from their homes and torn from their native context to be shown in museums and galleries in the West as 'works of art', is similarly dealt with, for there is no longer any need to agonise over the essential qualities of the work in order to determine whether or not it *is* art. It becomes art to the extent that it is considered *as* art. For Kant, the distinguishing characteristic of the judgement of taste is that it is 'disinterested' (Kant, 1952, pp 42–4) which is to say that the enjoyment involved is not conditioned by any external interests, as is the case, for example, with what Kant calls 'delight in the good', which is practical.

> *Taste* is the faculty of estimating an object or a mode of representation by means of a delight or aversion *apart from any interest*. The object of such a delight is called *beautiful*. (ibid., p. 50; emphasis in original)

Morawski summarises some of the difficulties involved in operating with this concept of disinterestedness as the defining characteristic of aesthetics, in particular the fact that it is impossible in practice to be disinterested, if this means detaching one's aesthetic experience or attitude from the rest of one's experience (Morawski, 1974, p. 11) But he concedes that if disinterestedness means apracticality, then it is a more helpful concept. In any case, the argument that there is a peculiarly aesthetic attitude which may be applied to paintings, sunsets, or even functional objects is, while unexceptionable, of very limited use. On the one hand it does describe what occurs in choosing to look at something as art or as an aesthetic object but on the other, it is not, in the end, an answer to the question 'What is art?'. We may be prepared to define as art any object, even with original practical intention, so long as it is presented or perceived aesthetically, but a sunset does not thereby become art; so the category has to be narrowed to artefacts which may be so presented or perceived. Moreover, we still need to specify the nature of the 'delight' involved in appreciating something apart from any interest, something which Kant's later discussion (1952, p. 60) of the beautiful as that which pleases universally, without a concept, fails to do. The major advantage of a Kantian analysis is that it is non-essentialist, abandoning as it does the search for some essential features of either works of art or aesthetic experiences. Its weakness is the inadequacy of its analysis of the disinterested attitude itself, the actual relation of that attitude to other experiential factors, and the kind of pleasure produced as a result of its exercise.

Phenomenological theories of art have provided far more sophisticated accounts of the nature of the aesthetic attitude (see Ingarden, 1931; Dufrenne, 1953; Natanson, 1962). Aesthetic experience is characterised in terms of its own 'intentionality', based on the 'bracketing' of this experience separately from other, outside experience. The phenomenological reduction makes it possible for the philosopher to isolate the aesthetic from all other types of attitude and, in particular, from the attitude of everyday

life. Schutz's (1967a) essay on 'multiple realities' is illumin-
ating in demonstrating what is involved in the phenomeno-
logical reduction, although he does not say very much
about art or the aesthetic attitude in this essay. He discusses
first the natural attitude of everyday life and its practical or
pragmatic motive, stressing the intersubjective nature of
the world as perceived in the natural attitude and the para-
mount reality of this world of practical engagement, or
working. Except for the critical scepticism of philosophers,
this world of everyday life is not subject to doubt, but is
taken for granted. The phenomenological reduction, the
epoché, is usually proposed (for example, by Husserl) as a
philosophical method for 'bracketing' this everyday know-
ledge in order to build an epistemology on sure grounds
rather than on common-sense assumptions. But as Schutz
here demonstrates, it can be employed equally well to
isolate and present other modes of knowing apart from the
epistemological: the natural attitude itself can 'bracket'
scientific or philosophical inquiry or doubt (Schutz, 1967a,
p. 229). Schutz goes on to argue, following William James,
that there are many sub-universes, or rather provinces, of
meaning, each with its own cognitive style. Examples of this
are the world of dreams and the world of scientific theory.
In each case, we switch from the natural attitude, via a kind
of *shock*, to another province of meaning, with its associ-
ated attitude.

> There are as many innumerable kinds of different shock
> experiences as there are different finite provinces of
> meaning upon which I may bestow the accent of reality.
> Some instances are: the shock of falling asleep as the leap
> into the world of dreams; the inner transformation we
> endure if the curtain in the theater rises as the transition
> into the world of the stageplay; the radical change in our
> attitude if, before a painting, we permit our visual field
> to be limited by what is within the frame as the passage
> into the pictorial world; our quandary, relaxing into
> laughter, if, in listening to a joke, we are for a short time
> ready to accept the fictitious world of the jest as a reality

in relation to which the world of our daily life takes on the character of foolishness; the child's turning toward his toy as the transition into the play-world; and so on. (Schutz, 1967a, p. 231)

These provinces are finite, because there is no necessary compatibility or consistency between any two such provinces (for example, between dreams and science, or between the natural attitude and art) and each province has its own peculiar 'tension of consciousness' (ibid., p. 232). The natural attitude, however, is the paramount reality, and Schutz maintains that all the other provinces of meaning may be considered as its modifications (ibid., p. 233; see also Schutz, 1967b, pp. 341–3).

As I have said, Schutz does not elaborate on the characteristics of the aesthetic attitude, but we may attempt an exercise which is similar to his analysis of the world of dreams or of scientific theory and try to identify the main features of the aesthetic attitude in terms of time perspective, experience of one's self, form of sociality, and so on. Other phenomenologists of art have specified the constituents of the aesthetic attitude (see, for example, Bensman and Lilienfeld, 1968). Like Kant's aesthetics, this approach avoids the dangers of essentialism while proposing the basis for a theory of art. Like Kant, however, Schutz and other phenomenologists cannot attempt to answer the question of what art is, although they can tell us what is involved in seeing something *as* art. Their work contains a potential theory of aesthetic value, too, since it is possible to discuss aesthetic merit in terms of the success or otherwise of the specific features of a work of art in meeting the requirements of the aesthetic attitude. (See Ingarden, 1972, for a phenomenological argument for distinguishing artistic value from aesthetic value.)

Such a theory would need to be worked out, however, and it would be likely to face some of the problems which confront other accounts of aesthetic value, discussed earlier. The great advantages of phenomenological aesthetics in relation to Kantian aesthetics are, first, its far more

careful and detailed spelling out of the nature of 'disinterestedness' as the crucial aspect of aesthetic experience, and, secondy, its acknowledgement that even the aesthetic, in all its disinterestedness and detachment from the practical, is implicated in and dependent on the natural attitude. This leaves the way open for a proper investigation of the manner in which the production and enjoyment of art are related to extra-aesthetic factors of social life. Thus while the aesthetic attitude may be described as disinterested and as a province of meaning which is finite in respect of other provinces of meaning, entered only by a leap or 'shock', it is also related to other provinces, both by their coexistence in a single consciousness and by the guaranteed paramount reality of the natural attitude. The development of the notion of the aesthetic attitude, through the work of phenomenologists, is a step in the direction of a sociologically informed aesthetics, and hence a more adequate theory of art. Since I am by no means claiming that it is an entirely adequate theory of art, however, there is no need here to rehearse the particular limitations of the phenomenological method itself either in its pure Husserlian form or in its existentialist and Schutzian modifications. The point of the foregoing discussion has been to indicate that the internal debates and dynamics of the philosophy of art have tended towards a social theory of art.

What I have called the 'institutional theory of art' has a similar and even stronger tendency, for it perceives art in terms of its social, institutional definition. Wollheim appears to be inclining towards this view in his discussion of how new arts are established as art, for he argues that in a context in which there are already certain arts in existence, whether or not a particular form is an accredited vehicle of art will be determined

> by the analogies and the disanalogies that we can construct between the existing arts and the art in question. In other words, the question will benefit from the comparatively rich context in which it is asked. It is, for instance,

in this way that the question, Is the film an art? is currently discussed. (Wollheim, 1980, p. 152)

The institutional theory of art defines art by reference to those objects and practices which are given the status of art by the society in which they exist. Wollheim's comment on film is in line with this kind of definition, for he appears to be suggesting that whether or not a new form is 'art' is a matter which is settled empirically, by looking at such works and forms which are already so accredited. However, in a short essay included in the second edition of *Art and its Objects* he rejects the institutional theory of art, or at least its strong version, which he defines as follows:

> By the Institutional theory of art I mean a view which offers a definition of art: the definition it offers purports to be non-circular, or, at least, not viciously circular: and it defines art by reference to what is said or done by persons or bodies of persons whose roles are social facts. (Wollheim, 1980, p. 157)

Wollheim's main objection to this theory is that if the status of art is conferred by certain institutionally located people by virtue of their roles, then they must perform this task using good reasons, and not merely relying on their own position. If, however, it is those reasons themselves which, when known, provide all we need to identify works of art, without the help of institutional representatives of the art world, in this case, it is not an institutional theory at all. Wollheim none the less concludes by reasserting the importance of recognising the institutional nature of art in many respects: 'To argue for the rejection of the Institutional theory of art is not to deny a number of theses which assign what may be thought of as 'institutional' characteristics to art' (ibid., p. 166). He repeats some of these theses, contained in the main body of his text – for example, the fact that new arts establish themselves on the basis of analogies with existent art, that individual works of art belong to traditions and derive many of their characteristics from

earlier works of art, and that the production of art is surrounded by factions and coteries. His objection to the institutional theory itself is that it purports to offer a definition of art, or to identify its essence.

Unlike theories of the aesthetic attitude, institutional theories of art, as Wollheim says, are interested primarily in the question 'What is art?'. An institutional definition of art would, of course, have nothing to say about the nature of the aesthetic experience; nor would its approach to the question of aesthetic value be obvious, though this could probably also be discussed in terms of conferment of merit by people of appropriate status. Indeed, one of the major institutional theorists cited by Wollheim, George Dickie, has explicitly attacked the concept of the aesthetic attitude (see Dickie, 1969). I shall not attempt to adjudicate in this debate since this is not intended as a contribution to the philosophy of art. It is clear that theories of the aesthetic attitude are able to account for certain aspects of the aesthetic which institutional theories cannot discuss (for example, how non-art may be considered in the aesthetic mode); conversely, institutional theories offer the possibility of explaining why certain works or groups of works are considered appropriate objects for aesthetic attention. Both types of theory, incidentally, are able to deal with the case of ready-mades, earthworks, or bricks, which continue to fascinate aesthetic theorists (see Wollheim, 1980, p. 165). Similarly each type of theory has its own weaknesses, more than adequately pinpointed by its opponents in the literature. Most interesting from our point of view is the fact that both approaches have abandoned the field of pure philosophy, and incorporate the contingent and the social into their analyses. I have already discussed this development in the case of theories of the aesthetic attitude with reference to the work of phenomenologists. The sociological nature of the institutional theory of art is self-evident, for the theory relies on the social roles and institutions in which art is produced and accredited.

I have argued that there has been an internal movement of

aesthetic theory towards a more sociological approach. This by no means characterises all work being produced in the philosophy of art, for, as I have already indicated, much of this work continues to be traditional analytical theory. Even the phenomenology of art often retains a clear distance from the social aspects of consciousness. Nevertheless, the trend towards the sociological is a significant one, based as it is on the perception that a pure aesthetics is impossible. The trend is also fuelled by work which has been influenced by Wittgenstein's aesthetics, for to see art as a 'form of life' or in terms of ways of living (Wittgenstein, 1967, p. 11), or to discuss the aesthetic by referring to the criteria for the application of aesthetic terms (see Scruton, 1974, pp. 10–11) is to defer immediately to the social and the contextual. Gombrich's (1960) important work on art and perception has also contributed to this development by demonstrating that the experience of works of art is always and necessarily interpretive. Wollheim quotes Gombrich's examples of the way in which extrinsic knowledge inevitably intrudes into aesthetic perception.

> 'What strikes us as a dissonance in Haydn', Gombrich writes, 'might pass unnoticed in a post-Wagnerian context and even the *fortissimo* of a string quartet may have fewer decibels than the *pianissimo* of a large symphony orchestra.' Again, Gombrich cites Mondrian's *Broadway Boogie-Woogie* which, he says, in the context of Mondrian's art is certainly expressive of 'gay abandon': but would have a quite different emotional impact on us if we learnt that it was by a painter with a propensity to involuted or animated forms, e.g. Severini. (Wollheim, 1980, p. 57)

Gombrich's book also shows that knowledge and interpretation play a part in even the most straightforward perception of works of art, including the decoding of three dimensions from two dimensions, or the projection involved in seeing paint-strokes as blades of grass, stitches, or hair. Although Wollheim finds some difficulties with Gombrich's argument

that we can only really understand a work of art in relation to the repertoire of its producer, or the context and conventions in which it is produced, he endorses the basic point, that there can be 'little doubt about the important part that collateral information does play in our aesthetic transactions' (Wollheim, 1980, p. 66).

For Gombrich and Wollheim that collateral information is more or less restricted to knowledge about art – conventions, genres, and so on – but I would go further and insist that aesthetic transactions are also always affected by and integrated into extra-aesthetic experience and information. Schutz's analysis of the 'multiple realities' of consciousness is based on the primacy of the natural attitude and the contiguity of finite realities within a single consciousness. We need not adopt the phenomenological method or vocabulary to perceive that (as the hermeneutic tradition also informs us) interpretation is always from the point of view of the existential and historical position of the interpreter, as well as taking as its point of departure the meanings contained in the work of art itself. The appreciation and evaluation of works of art, then, despite the possibility of adopting the distinctively aesthetic mode of attention, are ultimately inseparable from the non-aesthetic aspects of existence. This is not to claim that we judge works of art by political or moral standards; it may still be the case that there are specifically aesthetic criteria (and ones which may be trans-historical and trans-situational) employed in such a judgement. It is to claim that the way in which we apprehend the works in the first place is a function of our everyday extra-aesthetic existence.

The writers I have been considering differ not only over what they take to be the key question for aesthetic theory (the nature of art, the properties of works of art, the features of the aesthetic experience, and so on), but also in terms of their identification of the distinctive characteristics of the aesthetic. For Gadamer, it is the element of surprise involved in the apprehension of a work of art (Gadamer, 1976, p. 101). Goodman names four 'symptoms of the aesthetic': syntactic density, semantic density, syntactic

repleteness and exemplification (Goodman, 1976, pp. 252–5). Morawski lists four attributes of works of art, namely, that they are structures of sensuously given qualities, that they are relatively autonomous, that they are artefacts of skill or virtuosity and that they are individual expressions (Morawski, 1974, pp. 98–120). We have yet to ascertain what is the specific nature of the aesthetic, and this question has been left to one side in this chapter. Commitment to a phenomenological aesthetics or to the institutional theory of art or to an aesthetics of objects, experience, or emotions does not in itself entail commitment to any particular theory of the specificity of art. Nor, as I have already suggested, does an aesthetics which stresses the social nature of artistic experience thereby collapse the aesthetic into the political or the social. Morawski's emphasis on the relative autonomy of the structure of the work of art, in the context of a Marxist aesthetics, underlines this point. I want to conclude this chapter by proposing that there is now an area of common ground between those philosophers of art I have been discussing in the preceding pages, and those sociologists of art whose work avoids the pitfalls and mistakes of reductionism outlined in Chapter 2.

The reference to the work of Stefan Morawski already demonstrates this overlap in the convergence of traditionally separate disciplines and approaches in the work of one person. In Marxist aesthetics, as in other areas of study within Marxism, the artificiality and distortion of the segregated disciplines in the human sciences become apparent, for the areas of human experience and existence with which these disciplines purport to deal are not themselves segregated, but form part of a unified totality. As Lukács saw years ago, the separation of disciplines results from the fragmentation of life and experience in capitalist industrial society (Lukács, 1971). The gradual recognition that the inadequacies of the various disciplines derive from this false isolation is part of an attempt to reintegrate these fragments, and is at the same time an implicit critique of our fragmented society. Although it is by no means the case that all the worthwhile or valuable work, in aesthetics or in other

disciplines, is being done by Marxists or neo-Marxists, it is not surprising that a good deal of it is conducted within this frame of reference, for an inter-disciplinary approach to the subject-matter is likely to be based on the view that academic divisions duplicate and reinforce social divisions in society.

We have already seen that Bourdieu has carefully analysed some of the mechanisms by which dominant groups retain their position of power and enhance their status, in particular by inventing the category of the 'aesthetic' as a universal, transcendent entity. In an attempt to reverse the historical separation of subject-matter, Marxist sociologists of art, literary critics and art historians have engaged in debate with philosophers of art, discovering their interdependence and their commonality of interests. Indeed, as is probably already clear from an earlier discussion in this book, it is not always obvious who is a sociologist of art, rather than a philosopher, critic, or historian— Morawski is one such example. Raymond Williams is a literary critic and literary historian; the first chapter of his latest book (Williams, 1981) is entitled 'Towards a sociology of culture'. The art historian Max Raphael, whose work has recently been the subject of renewed interest in Marxist aesthetics (see Tagg, 1980) argues for the development of a sociology of art, which he appears to equate with a Marxist theory of art (for example, Raphael, 1979, p. 76).

But whatever the institutional location of the particular writers, or the academic training and orientation on which their work is based, those proposing a sociological theory of art are increasingly insisting on the 'relative autonomy' or specificity of art itself. Even in 1933 Raphael was aware of the importance of this non-reductionist approach and it is possible that his current popularity and influence is connected with the relatively recent general recognition of its validity. He proposes that the sociology of art and art criticism are complementary and equally essential.

The reciprocal relations between these two groups of sciences express the relation that obtains between the

relative autonomy of the ideological domain of art and its dependence upon the fundamental facts of social life ...The essential feature of materialist dialectics is not only that it grasps all the facts of social life in terms of a single method, but also that it leaves relatively autonomous the specificity of each domain. (Raphael, 1979, pp. 84–5)

The specificity of the aesthetic is also preserved in the work of Della Volpe (1978), in this case with respect to poetry. He outlines his project: 'My aim in the present book is to present a systematic exposition of an historical-materialist aesthetic, and by extension, an orderly sociological reading of poetry and art in general' (p. 11). This sociological reading, far from reducing the aesthetic or the poetic to the social and historical, elaborates in great detail the specific constituents of poetry. His definition of poetry as 'polysemic characteristic typicality' (ibid., p. 173) is not unlike Goodman's characteristics of density, repleteness and exemplification. The need for a sociological reading of literature does not obviate the parallel need for an analysis of the specificity of that literature. On the contrary, the analysis of the discourse of the poem, its own specific 'intellectuality', is essential to the sociological understanding (ibid., pp. 20–4).

From the point of view of the philosophy of art, then, the social co-ordinates of the aesthetic are becoming increasingly apparent. From the point of view of the sociology of art, the valuable contribution of much work in aesthetics is achieving some recognition, for it provides a vocabulary and an orientation which enables us to approach the question of the specificity of the aesthetic. In the belief that the experience and evaluation of art are socially and ideologically situated and constructed, and at the same time irreducible to the social or the ideological, I turn in the next chapter to consider some attempts to describe this specificity.

5

The Specificity of Art

The growing agreement among sociologists of art that it is essential to pay attention to the specificity of art disguises the fact that different people mean different things by this phrase. Stuart Hall, in a survey of developments in cultural studies at the Centre for Contemporary Cultural Studies in Birmingham, considers that the recognition of the specificity of culture was one of the major contributions of structuralism.

> If the weakness of the positions outlined earlier was their tendency to *dissolve* the cultural back into society and history, structuralism's main emphasis was on the specificity, the irreducibility, of the cultural. Culture no longer simply reflected other practices in the realm of ideas. It was itself a practice – a *signifying* practice – and had its own determinate product: meaning. To think of the specificity of the cultural was to come to terms with what defined it, in structuralism's view, as a practice: its internal forms and relations, its internal structuration. (Hall, 1980, p. 30; emphasis in original)

Raymond Williams, in a discussion of 'specificity' in his most recent book, argues that the fact that the aesthetic takes many different forms in different societies 'does not mean that everything, including the most specifically artistic and most specifically aesthetic processes, has to be dissolved into some indiscriminate general social or cultural practice' (Williams, 1981, p. 129); Peter Fuller criticises John Berger's work on the grounds that 'it places insufficient emphases on the specificities of painting' (Fuller,

1980c, p. 8); and John Tagg commends Raphael's sociology of art, which opposes to a reductionist, economistic approach one which is able to deal with 'the specificity of cultural and ideological forms' (in Raphael, 1979, p. ix). The notion of 'specificity' is sometimes (for example, by Williams) taken from Lukács's major work on aesthetics, *Die Eigenart des Ästhetischen* (1963), either as a translation of *Eigenart* (which Lichtheim translates as 'peculiarity', see Lichtheim, 1970, p. 119), or as a translation of one of the central terms in this work, *Besonderheit* (Lukács, 1963, vol. 2, ch. 12; see also Lukács, 1969); Williams translates the latter, or its Hungarian equivalent *kulonosség*, as 'specificity' (1977, p. 151). Most people agree that the concept of specificity is of central importance in a sociology of art (although Williams is critical of Lukács's particular application of it, see Williams, 1981, pp. 127–9). But, as we shall see, they do not necessarily all mean the same thing by the term. I shall suggest that there are at least three different senses in which 'specificity of art' is used, only the last of which is directly relevant to the concerns of this book.

In its first sense, the specificity of art refers to the historical separation of artistic activity from other areas of social life, and the concomitant specialisation of aesthetic modes of perception. As Williams says,

> The attempt to distinguish 'art' from other, often closely related, practices is a quite extraordinarily important historical and social process. The attempt to distinguish 'aesthetic' from other kinds of attention and response is, as a historical and social process, perhaps even more important. (1981, p. 126)

His critical comments on Lukács's attempt to define the specificity of art rest on the fact that the account given by Lukács of the emergence of the *aesthetic* from the *practical* and the *magico-religious* is insufficiently materialist, based on terms which are too broad and categorical. Nevertheless, he is interested in the same kind of project himself, namely,

to identify the processes involved in the separation of the aesthetic from everyday life. Against Lukács, he argues that

> The necessary distinctions are not to be found at the level of categorical separation but rather at the level where they are in fact produced, which is that of both general and specific cultural and social orders. (ibid., p. 129)

Specificity here consists in the particular historical emergence of the aesthetic, as a category distinct from the practical, the religious and the everyday.

This is, as I have already suggested in the first chapter, an important and valid exercise, for we do need to know how the category of the aesthetic (as well as those of art, the artist and aesthetics) developed historically, and how it came to be differentiated from functional and practical enterprises. It should perhaps be noted, however, that although such an account does indeed find a model in Lukács's aesthetics, it does not take into account his central concept of *Besonderheit*: the first chapters of his treatise deal with the emancipation of art from everyday life and its gradual separation from magic, as a unique kind of reflection (*Widerspiegelung*), but he goes on to discuss the specific features *of* art, thus differentiated, first by identifying its abstract forms (rhythm, symmetry, proportion and ornament), and then by addressing himself directly to the question of 'specificity' in art (Lukács, 1963, Vol. 1, ch. 4; Vol. 2, ch. 12; see also Királyfalvi, 1975, chs 3, 5). Rather than looking at the specificity *of* art, he proposes 'specificity' as an aesthetic category in itself. In other words, his argument is that the aesthetic is identified or defined by its particular category of specificity, which falls between the categories of *individuality* and *universality*. (This theory of the aesthetic as founded on a particular category of thought which mediates between the individual and the general is related in an important way to his continuing focus on the notion of the 'type' as crucial in realist literature, although this cannot be pursued here; see Királyfalvi, 1975, ch. 5.) So Williams is wrong to equate Lukács's notion of *Besonderheit*

with his account of the historical emergence of art, for it has
nothing to do with the question of what is specific *about* art
or its development. We could, perhaps, say that for Lukács
the specificity of art consists precisely in its category *of*
specificity. For although Lukács too is concerned to discover
the peculiarity (*Eigenart*) of the aesthetic – its own specific
mode of existence and experience – his discussion of *Beson-
derheit* is an attempt at investigation and not a formulation
of the problem.

Arguments in favour of the specificity of art, then, are
sometimes arguments about the actual isolation of art and
its associated practices from practical activities and from
the rest of social life, and about the historical and social
processes in which this isolation was produced. However,
the second kind of emphasis on specificity takes up the
quite different question of the independence of art in rela-
tion to social or economic factors. Here the concepts of
'specificity' and 'relative autonomy' are more or less inter-
changeable. This line of argument, also important and rep-
resenting a valuable development in the recent sociology of
art, maintains that although art is a social product (which
is, however, thanks to the historical separation of the aesthe-
tic as a distinct sphere, regarded and experienced as remote
from its social determinants) it is also the case that it is not
simply a reflection of its social origins. This is the critique of
the simple base–superstructure model of culture (see
Wolff, 1981, chs 3, 4). The relative autonomy of art and
culture consists in the specific codes and conventions of
artistic representation, which mediate and (re)produce
ideology in aesthetic form. So art, while being the product
of social, political and ideological factors, manifests its own
specificity in this particular sense. It is in this way that
Stuart Hall, quoted above (page 85), understands the
notion of specificity: culture as a signifying practice, with
its own internal forms, relations and 'structuration'. (I
should also add that, although I have taken up another
aspect of his work, concerning his use of Lukács's concept
of specificity and the discussion of the emergence of the
aesthetic in history, Williams too is concerned to investigate

the forms, codes and signifying practices of the arts, and indeed devotes a good deal of two of his books to their analysis, see Williams, 1977, pt III; 1981, ch. 6.)

In the hands of sociologists of art and Marxist aestheticians, this particular notion of the specificity of art does not imply any universalistic or trans-historical features. On the contrary, the forms of literature and art are seen as historical and as changing. For signifying practices and forms of representation, although they offer resistance to the straightforward expression of ideology in art by their relatively autonomous existence, are themselves the product of political and ideological processes. Thus Tony Bennett, in his presentation of the work of the Russian Formalists as an important potential contribution to Marxist aesthetics, both insists on the specificity of texts, as demonstrated by Formalist techniques and tools of analysis, and maintains that this specificity must be conceived historically (Bennett, 1979, p. 154). He argues that any view of literature or of the aesthetic as characterised by universal or eternal features or modes of cognition, as maintained by traditional, bourgeois aesthetics, must be rejected (ibid., pp. 12, 145–6). But the analysis of texts must include an account of their 'literariness' (to use a Formalist term); it must investigate the way in which, and the literary devices through which, texts transform and represent thought and ideology. As Terry Eagleton says: 'The literary text is not the "expression" of ideology, nor is ideology the "expression" of social class. The text, rather, is a certain *production* of ideology' (1976, p. 64; emphasis in original). This realisation has led to a proliferation of studies of the text (here understood broadly, to include painting, film, and so on, as well as literary texts). Formalist techniques of textual analysis have been important, as have developments in semiotics and structuralism which enable us to comprehend texts as complex and relatively autonomous signifying systems and codes. This is the second sense in which the specificity of art is rightly acknowledged.

Another aspect of this particular argument for the relative autonomy of art is the reference to the workings of

what Eagleton calls the 'literary mode of production' (1976, p. 45). Here, the study of how a text produces or works on ideology involves a close examination of the institutions and processes of artistic production: the operation of publishers, patrons, distributors, gallery owners, entrepreneurs and critics. Since all these people and the work in which they are engaged are implicated in the task of cultural production, and in the mediation of products from producer to cultural consumer, they constitute an important, relatively independent, level of determination. As is the case with cultural codes and signifying practices, the institutions of culture also represent an irreducible specificity of the aesthetic sphere. But although this is a crucial part of any sociology of art, it is not what I intend to explore as the relevant notion of 'specificity' for a sociological aesthetics. (For a discussion of the institutions and practices of culture, see Williams, 1981, particularly chs 2 and 3).

Having made some distinctions in the use of the term, I now turn to that notion of specificity which was suggested at the end of Chapter 2. Instead of considering specificity as the historical separation of art from social life or as the relatively autonomous operation of artistic codes and practices, I shall be concerned with work which attempts to identify the specific characteristics of art; for we require such an account in order to approach the question of what is involved in aesthetic evaluation, and even the question of the nature of aesthetic pleasure and gratification. Without prejudging the results of such an inquiry, however, it can be asserted that the project itself need not necessarily be an essentialist one – that is, it need not be a search for universal aesthetic qualities. Bennett's insistence that aesthetics must be historicised may also apply to the theory of the specificity of art in the present sense. As we shall see, for some authors the aesthetic is a historical category; for others it is a trans-historical, human universal.

At present there are three major contenders for a theory of aesthetics within a sociological or materialist framework. These are *discourse theory, the philosophical anthropology*

of art and *psychoanalytic theories of art*. A possible fourth contender is the approach which tries to discover the specific features of the aesthetic and to locate this analysis within a materialist history of art and society, an example of which would be Lukács's discussion of rhythm, symmetry, and so on, mentioned earlier (page 87 above). However, it is probably the case that such theories invariably either revert to idealist, non-sociological categories (in which case they are of no use for our project) or they depend on a philosophical anthropology – a theory of human nature (in which case they fall under the second of the three headings). I shall now present each of the three approaches through the work of some of its proponents and assess the potential of each for an adequate aesthetic theory.

Discourse theory, and particularly the work of Foucault, has been increasingly influential in cultural studies in recent years. Foucault himself has not produced a full-length study of the aesthetic discursive formation, to match his analyses of the discourses of medicine (1973), discipline (1977), power (1980b) and sexuality (1979a). He has, howevr, alluded to issues in aesthetic theory and artistic practice, which have provided important orientations in this area of work for his followers. (For example, his discussion, 1979b, of the concept of 'the author'.) The following quotation from an article by Ernesto Laclau clarifies the notion of 'discourse' (though perhaps not exactly in terms which Foucault would himself approve):

> By 'discursive' I do not mean that which refers to 'text' narrowly defined, but to the ensemble of the phenomena in and through which social production of meaning takes place, an ensemble which constitutes a society as such. The discursive is not, therefore, being conceived as a level nor even as a dimension of the social, but rather as being co-extensive with the social as such. (Laclau, 1980, p. 87)

Meaning, consciousness and even the objects of thought are perceived as constructed in discourse. Laclau's article

proposes the radical and controversial thesis that class antagonism is itself a discursive construction, on the grounds that negation cannot be a predicate of real objects but is rather produced in 'discursively constructed positionalities' (ibid., p. 89).

However, discourse theory does not necessarily extend to ontological 'bracketing' of the real world but it does maintain that the way in which we perceive the world is a function of discourse. Thus Foucault's work on sexuality demonstrates the historical construction of problems and issues in the area of sexuality by what he calls 'the incitement to discourse' (1979a, pt 2, ch. I). Against the view that sexuality has been repressed since the advent of capitalism, he argues that the multiplication of discourses about sexuality (medical, psychoanalytical, and so on) illustrates the contrary – the institutional incitement to speak about sexuality.

A first survey made from this viewpoint seems to indicate that since the end of the sixteenth century, the 'putting into discourse of sex', far from undergoing a process of restriction, on the contrary has been subjected to a mechanism of increasing incitement; that the techniques of power exercised over sex have not obeyed a principle of rigorous selection, but rather one of dissemination and implantation of polymorphous sexualities; and that the will to knowledge has not come to a halt in the face of a taboo that must not be lifted, but has persisted in constituting – despite many mistakes, of course – a science of sexuality. (Foucault, 1979a, pp. 12–13)

In *The Archaeology of Knowledge* (1972) Foucault had already indicated the lines on which such a study (an 'archaeology') of sexuality might be undertaken. He also suggested an archaeology of art, in terms of the discursive formation involved.

In analysing a painting, one can reconstitute the latent discourse of the painter; one can try to recapture the

murmur of his intentions, which are not transcribed into words, but into lines, surfaces, and colours; one can try to uncover the implicit philosophy that is supposed to form his view of the world. It is also possible to question science, or at least the opinions of the period, and to try to recognize to what extent they appear in the painter's work. Archaeological analysis would have another aim: it would try to discover whether space, distance, depth, colour, light, proportions, volumes, and contours were not, at the period in question, considered, named, enunciated, and conceptualized in a discursive practice; and whether the knowledge that this discursive practice gives rise to was not embodied perhaps in theories and speculations, in forms of teaching and codes of practice, but also in processes, techniques, and even in the very gesture of the painter. (Foucault, 1972, pp. 193–4)

The painting, then, must be understood as a discursive practice. Foucault's critical comments on the notion of 'the author' (1979b) hinge on the identification of another aesthetic discourse, that of literary history. I have already referred (page 16 above) to Griselda Pollock's use of the notion of discourse in a critique of art history. She shows, through a discussion of the treatment of Van Gogh by art historians and others, how the myth of the artist as creator and as single source of meaning is constructed and sustained in the discourse of art history:

The construction of an artistic subject for art is accomplished through current discursive structures – the *biographic*, which focuses exclusively on the individual, and the *narrative*, which produces coherent, linear, causal sequences through which an artistic subject is realised. (Pollock, 1980, p. 59; emphasis in original)

The notion of a discursive practice or a discursive formation has proved to be a valuable asset in the attempt to avoid a reductionist sociology of art and culture, since it posits as relatively, if not totally, autonomous the level of the cultural

(see Hall, 1980, p. 37). To that extent, it provides a way of conceptualising the specificity of art in the second sense discussed above – that is, the aesthetic as relatively autonomous of its economic and social determinants. Foucault has been criticised for an unwillingness, or an inability, to relate discursive formations to one another or to any fundamental determining social features (Hall, 1980, p. 37; Mercer, 1980, p. 10) but discourse theory need not plead agnosticism on the question of material determinants of discourses, as is made clear by Pollock's article and work by others and as is indicated by Foucault's own current preoccupation with the question of power; it is potentially compatible with a sociological theory of knowledge and, in this case, of art. The fact that meaning, subjects, and so on, are produced in discourse should not preclude the observation that discourses themselves are produced somewhere, even if, as Laclau says, the constituents of that determining source can in turn only be apprehended discursively. So discourse theory offers us a notion of the specificity of the aesthetic in terms of the particular discursive practices which constitute it, while leaving open the possibility of relating the aesthetic and its discourse to extra-aesthetic factors. This specificity will consist in the elements and terms of aesthetic (as opposed to artistic or art-historical) discourse, and may include, for example, some of the features listed by Foucault in the brief discussion of painting in *The Archaeology of Knowledge* quoted above. The specificity of art is identical with the discourses of the aesthetic.

In one way, this is entirely adequate as a resolution of the problem of the aesthetic. Not only is the aesthetic conceived as relatively autonomous of the social and political, it is also presented as manifesting its own particular qualities, understood as a function of discourse. So, as Foucault suggests, we can inquire whether space, colour, proportion, and so on, are 'named, enunciated, and conceptualized in a discursive practice', and relate this information to techniques, teaching and codes of practice. In this case, a 'good' work of art is one which is so designated by the rules and practices of aesthetic discourse. This produces a theory of aesthetic

value which is both internalist (in that it does not reduce aesthetic value to moral or political value) and historicist (in that it recognises the contingent nature of discourse). The weakness of discourse theory with regard to aesthetics, though, apart from those general problems which critics of Foucault have already identified, is that it cannot take on the problem of aesthetic pleasure. It is difficult to see how the enjoyment involved in the appreciation and assessment of works of art can be accommodated in discourse theory or portrayed as anything other than an effect of discourse, although the rational judgement of the qualities and features of a work as well-balanced, well-constructed, har-monious, and so on, is part of a discursive practice. From the point of view of discourse theory, this may be construed as an advantage rather than a weakness, however, for such a critique may retort that questions of 'subjective exper-ience' or 'aesthetic appreciation' are wrongly formulated. If we accept the view that such issues in aesthetics *can* be reformulated in terms of discursive practices, then it may well be that a new theory of aesthetic judgement can be developed in terms of discourse analysis, and in retreating from this challenge in the present context, I by no means rule this out as a promising possibility.

The second attempt to provide a materialist aesthetics, which I have called a philosophical anthropology of art, rests on the belief that there are certain human universals which find expression or satisfaction in art. In particular, I shall consider some recent work by Raymond Williams and by Peter Fuller, which rescues such a notion of the aesthe-tic. Both have been influenced by the writings of Sebastiano Timpanaro on Marxist theory (see Williams, 1979, p. 340, 1980; Fuller, 1980a, pp. 18−23). Timpanaro's Marxism is materialist in a strict sense, in its emphasis on nature and biology as underpinning the social and historical.

> The task is to go beyond the indications given by the Marx-ist classics, fundamental as they are, and to construct a 'theory of needs' which is not, as so often, reduced to a

compromise between Marx and Freud, but which con-
fronts on a wider basis the problem of the relation
between nature and society. The accusation of 'biolog-
ism' or 'vulgar materialism' is, at this point, obvious and
foreseen. If this label refers to an immediate reduction of
the social to the biological and a failure to recognize the
radically new contribution made by the appearance of
labour and relations of production with respect to merely
animal life, then I hope that these essays are already fore-
armed against any such error ... If, however, as is too
frequently the case in the Western Marxism of our cen-
tury, what is meant is denial of the conditioning which
nature continues to exercise on man; relegation of the
biological character of man to a kind of prehistoric pro-
logue to humanity; refusal to acknowledge the relevance
which certain biological data have in relation to the
demand for *happiness* (a demand which remains funda-
mental to the struggle for communism); then these pages
are deliberately 'vulgar materialist'. (Timpanaro, 1975,
p. 10)

He argues, against Western Marxists, that in their concern
to avoid vulgar materialism they have cast out materialism
altogether (ibid., p. 29). By materialism, he argues, we must
mean the priority of nature over mind, 'of the physical level
over the biological level, and of the biological level over the
socio-economic and cultural level' (p. 34), both in terms of
chronological development and in terms of continual
conditioning. Just as the economic and social structure
conditions the so-called 'superstructure' of ideas and con-
sciousness, so the even more basic structure of nature
conditions the social and economic. Timpanaro likens this
to a block of apartments, the economy being the first floor
which refuses to recognise that the ground floor (nature)
supports it, while insisting that the second floor (super-
structure) is dependent on it (ibid., p. 44). As constant
dimensions of human experience, he mentions 'the sexual
instinct, the debility produced by age (with its psychological
repercussions), the fear of one's own death and sorrow at

the death of others' (p. 50). He does not claim that these are eternal, or that they have any metaphysical or meta-historical status, but that they are long-lasting, and have much greater stability than historical or social institutions (p. 51).

It would be to deviate too far from my main concerns in this book to attempt an assessment of Timpanaro's argument, to consider the nature of Marxism as a materialism, or even to review the debates relating to his work. My main purpose is to show how sociologists of art and literature have used his work, and to make some preliminary comments on these developments. Timpanaro has himself given the example of the expression of these 'constant dimensions' in literature and poetry, which, despite historical variations, refer to the same underlying aspects of the human condition (Timpanaro, 1975, p. 50). Raymond Williams draws a slightly different kind of support for a 'materialist aesthetics' from Timpanaro's work, as the following reply to his interviewers, in the collection published as *Politics and Letters* (1979) makes clear:

When I read Timpanaro, I had the sense of an extraordinary recovery of a sane centre of the Marxist tradition, which it seemed to me had been largely forgotten or had persisted only among the dwindling number of natural scientists who were still Marxists. I was acutely aware of the potential importance and relevance of this problem for what has traditionally been called aesthetics, in particular. That is why I had more difficulty with the conclusion of the chapter entitled 'Aesthetic and Other Situations' than with anything else in the book [*Marxism and Literature*]. I was trying to point in the direction of this area by speaking of the quite physical effects of writing, which have certainly been overlooked in a sociologically oriented tradition. For there is a very deep material bond between language and the body, which communication theories that concentrate on the passing of messages and information typically miss: many poems, many kinds of writing, indeed a lot of everyday speech communicate what is in effect a life rhythm and

the interaction of these life rhythms is probably a very important part of the material process of writing and reading. (Williams, 1979, p. 340)

It is in this sense that Williams now argues that we must search for certain 'permanent configurations' (1979, pp. 325, 341; and see p. 25 above). But what these might be is not yet specified. Nor is their interaction with, or modification by, the acknowledged historicity of economic, social and ideological factors. Here I shall only point out that other developments in theory, Marxist and otherwise, have to my mind conclusively shown that 'human constants' are most elusive things, for they are the product of ideology, of childhood learning and of discourse. To take just one example of this, we may look at Timpanaro's uncritical reproduction of a statement by Labriola, to the effect that 'we are born naturally male and female' (Timpanaro, 1975, p. 49). As Foucault's work on sexuality (1979a, 1980a) demonstrations, however, and as psychoanalysis confirms from a different point of view, sex and gender are problematic concepts, and even the distinction between 'male' and 'female' is produced in language and ideology. So any notion of 'biological constants' is fraught with difficulties, and it remains to be proved that a 'theory of needs' is either possible or compatible with Marxism or sociology.

Peter Fuller, also inspired by Timpanaro and by Williams's interpretation of Timpanaro (Fuller, 1980a, p. 18) believes that aesthetics can benefit enormously from Timpanaro's work. His criticism of John Berger for failing to place sufficient emphasis on the 'specificities of painting' (Fuller, 1980c, p. 8) also invokes the 'relatively constant underlying human condition' which is represented in works of art (ibid., p. 9). In the essay on Berger this condition and these 'relative constants' are no better spelt out or justified than in Williams's brief comments. In a footnote, Fuller suggests that 'The aesthetic constitutes a historically specific structuring of relatively constant, or long-lasting, elements of affective experience' (1980c, p. 29). He continues:

The material basis of the 'spirituality' of works of art is not so easily dissolved. I think that it may lie in their capacity to be expressive of 'relative constants' of psycho-biological experience, which, however they may be structured culturally, have roots below the ideological level. (ibid., pp. 29–30)

Accordingly, his recent book *Art and Psychoanalysis* (1980a) pursues this investigation into the psycho-biological and I shall consider this account in the next section of this chapter. With regard to current proposals for a materialist aesthetics, based on a philosophical anthropology, or a theory of human universals, constants, or needs, it appears either that we must resort to a metaphysical or pre-sociological belief in some fundamental features of human nature, or that we need a supplementary theory of the production of human needs. It is the latter that psycho-analytic theories claim to provide.

In this last section I shall look fairly briefly at two attempts to introduce psychoanalysis into aesthetics in order to iden-tify the specificity of art. These are first, Fuller's use of post-Freudian, particularly Kleinian, psychoanalysis; and secondly, the influence of Lacan on literary theory and cultural studies. Again, this discussion is by no means inten-ded as any comprehensive account, and still less as a definit-ive assessment, but merely as an indication of some devel-opments in aesthetics which have some claim to specify the 'aesthetic', and a tentative judgement of their strengths and weaknesses.

Fuller devotes a long essay to the study of the *Venus de Milo* in terms of Kleinian theory. He begins with an account of the discovery of the statue in 1820, and the history of its travels, reception and interpretations in the nineteenth cen-tury. He then criticises his own earlier interpretation of the statue and its continuing appeal as relativist, explaining the response to the work in terms of the particular conditions in France and Europe at the time of its discovery (the intensifi-cation of the division of labour, the growth of industrial

capitalism, and so on; Fuller, 1980a, p. 98), and in terms of the very different conditions of its 'second re-incarnation' (p. 99) in the twentieth-century world of pin-ups and advertising. His present position is that the appeal of the *Venus* throughout history has always been the same, and with the help of Kleinian psychoanalytic theory he proceeds to outline what its appeal is. A brief discussion of Kleinian theory emphasises in particular the importance of the early months of life, the child's relationship with the mother, the ambiguous (or split) attitude to the breast as both good and bad, and the sadistic impulses towards the loved object, realised in 'phantasy' (Fuller, 1980a, pp. 112–15). The *Venus*, whose lack of arms is thus an integral part of its aesthetic appeal and not an unfortunate deficiency, is seen as 'a representation of the internal "Mother" who has survived the ravages of a phantasised attack' (ibid., p. 121).

> The Venus, in its mutilated state, evokes in its receptive viewers the affects attaching to their most primitive phantasies about savaging the mother's body, *and* the consequent reparative processes (Fuller, 1980a, p. 124; emphasis in original)

Taken as an example of the pleasure experienced in a work of art, Fuller's general conclusion is as follows:

> Perhaps we can say that an effective work of art is expressive of potentialities of human experience which remain relatively constant, and yet not every work of art draws upon the same components and emotions or combines them in the same proportions. Within what we now describe as the category of the 'aesthetic', a range, but by no means an infinite range, of 'basic emotions' and areas of experience are structured within culturally and ideologically inflected forms, which they may, or may not, succeed in 'transcending'. (ibid., p. 128)

So now the 'relatively constant' features of human experience are recast in terms of psychological processes, founded in biological needs and instincts.

The problems involved in defending one particular psychoanalytic theory against others, or against its critics, need not be rehearsed here. In the end, the advantages of Kleinianism over Freudianism or Jungian theory can only be either simply asserted or supported by reference to its superior explanatory (or therapeutic) power. The status of statements about basic instincts or universal psychological needs, however, is always problematic. Since they are not, in the end, amenable to proof or disproof, some have argued that it is more helpful to see them as metaphors, or interpretive accounts, than to construe them as causal statements. Fuller's aesthetics is subject to all the difficulties of an essentialist psychoanalytic theory, for it depends on what is ultimately an arbitrary belief in certain unprovable processes; although he is careful to say that different historical and social conditions will place emphasis on different psychological factors, there is still an absolute and essentially human set of such factors, prior to and determining of their specific historical manifestations. The psychoanalytic slant to a philosophical anthropology, while advancing the possibility of talking about such things as 'relative constants', and while providing a vocabulary and an analysis which locate and define them, in fact produces its own limitations. It is not just that basic instincts and primary processes, sadistic, reparative, or whatever, can never be conclusively demonstrated. More damaging is the way in which such a theory is totally closed to the possibility of the social construction and historical variability of primary psychological processes, as well as to the possibility of differential human experiences, for example, by males and females in given historical circumstances. Lacanian psychoanalytic theory lays claim to a more adequate account of the formation of the psyche in both these respects. (Timpanaro and Fuller, it should be noted, are both totally dismissive of Lacan's work and influence; Timpanaro, 1975, pp. 171–92; Fuller, 1980a, p. 22.)

Lacan's reading of Freud has provided an account of the formation of the (gendered) subject in relation to the acquisition of language. (For helpful summaries of this theory,

and of its relevance for cultural studies, see Weedon, Tolson and Mort, 1980; Coward, Lipshitz and Cowie, 1976; Heath, 1978; MacCabe, 1975, 1976.) The entry into the 'symbolic order' (the acquisition of language), linked as this is with the resolution of the Oedipus complex, can be shown to be gender-specific, given the differential relation of boys and girls to the 'primary signifier', the phallus. Further, Lacan's notion of the earlier 'imaginary' stage, when the child cannot yet distinguish between itself and the object of its imaginary identification, is useful in the analysis of cultural objects, where the imaginary, or the repressed, is said to find expression (see Metz, 1975; Barrett and Radford, 1979). For some writers, the possibility of subversive cultural activity consists in the workings of the imaginary, and this includes the feminist subversion of male discourse (Eagleton, 1978c; Kaplan, 1976), although the contribution of Lacanian analysis to feminist theory is disputed, for while it is argued by some feminists that the account of the constitution of the gendered subject is essential to the understanding of patriarchy, other feminists argue that the analysis itself, like that of Freud, is patriarchal because it posits the phallus as universal primary signifier rather than exploring the particular conditions in which it has gained this dominance.

Without believing that Lacanian psychoanalysis is the most useful theory of the constitution of the gendered subject, I would suggest that both positions may be correct, for it is essential to analyse the ways in which patriarchal society operates and the way in which it reproduces men's power over women, but it is equally important to incorporate this analysis into the historical and sociological context which will allow for variations, for example, with different stages of the history of the family, or in different cultures. It is important, too, to permit the possibility of conceiving of the end of patriarchal relations. As Elizabeth Wilson has written,

> The last thing feminists need is a theory that teaches them only to marvel anew at the constant recreation of the

subjective reality of subordination and which reasserts
male domination more securely than ever within theoret-
ical discourse. Psychoanalysis is of interest in its account
of sexual identity and its construction – indeed, in many
ways it is fascinating. More useful to contemporary
feminists may be theories of social change that speak to
aspects of the self not harnessed to the Phallic task-
master. To change the conditions of work – in the world
and in the home – might do more for our psyches as well
as for our pockets than an endless contemplation of how
we came to be chained. (Wilson, 1981, p. 76)

This criticism of the universalising tendency of psycho-
analysis with respect to gender is similarly applicable to the
Lacanian account of art and culture, in so far as this, too,
depends on psychoanalytic features which are both univer-
sal and ahistorical. In an important critique of recent devel-
opments in film theory in Britain, Kevin McDonnell and
Kevin Robins regret the influence of Lacan:

As this post-structural theory is taken up in British
cultural theory . . . it becomes a philosophical anthropol-
ogy, a theory of the 'human condition'. It is adopted as a
theory of the constitution of the subject within the
symbolic or cultural sphere . . . In our opinion the assimi-
lation of Lacanian theory has turned social theory back
to that philosophical or anthropological form from
which Marx sought to release it. Our main criticism in
this section is aimed at this ahistorical cultural anthropol-
ogy. (McDonnell and Robins, 1980, pp. 200–1)

It appears the Lacanian theory is no more exempt than
Fuller's Kleinian aesthetics from the charge of essentialism.
 Many of the critics of Lacan and his followers stress that
psychoanalysis does indeed have an important part to play
in sociological and Marxist analysis (for example, see
McDonnell and Robins, 1980, p. 202) for it provides a way
of conceptualising the constitution of subjects and the con-
struction of gender difference within social forms. By the

same token, it offers the possibility of the identification of those aspects of the personality, unconscious, or consciousness which respond to the particular features of the aesthetic. For that possibility to be fulfilled, however, we require a more adequate, historicised, theory of human experience than has so far been produced. For it appears that to identify the specific features of the aesthetic is either to postulate human universals, whether anthropological or psychological (which, I have maintained, is unacceptable), or it is to necessitate a historical-materialist theory of aesthetic gratification, in which psychoanalysis finds its place within a broader analysis which does not subsume the concrete and the particular within an all-embracing universal theory.

6

Towards a Sociological Aesthetics

The dual purpose of this book has been to insist on the relevance of sociology for aesthetics, and to defend aesthetics from sociological reductionism. I have argued that aesthetics itself has to be understood as a discipline with a social history. I have also sought to show that the terms, assumptions, and judgements which operate in traditional aesthetics are socially located and, in an important sense, ideological. The very products which aesthetics and art history posit as 'works of art' cannot be taken uncritically as somehow distinguished by certain intrinsic features, but must be seen as produced in that history by specific practices in given conditions. The evaluations of works which form the artistic tradition are performed by people who are themselves institutionally and structurally located, with the consequent ideological and partial perspective this gives them. The experience and appreciation of works of art, which is logically prior to their evaluation, is unavoidably implicated in the wider structures of consciousness, even though the aesthetic attitude involves a certain kind of distancing ('disinterestedness') of that experience from the practical attitude of everyday life. Thus, as I hope I have shown in Chapter 4, accounts of the aesthetic and of aesthetic experience move closer to the sociological as they provide more adequate descriptions of what is involved in the confrontation with art.

At the same time, the sociology of art ignores aesthetics at its peril. Elizabeth Bird (1979) has shown how the most apparently straightforward sociological account of a movement in art depended on implicit aesthetic judgements about

the works and painters studied. The principle of 'aesthetic neutrality' demanded by a positivistic sociology and assumed by the researchers to be operative turned out to be an impossibility. This was a study of the Glasgow school of painters between 1880 and 1930 which looked at the artistic groups, publics, artistic styles, and so on, involved in their work. Bird lists the difficulties involved in this research, starting from the problem of deciding who should be counted as artists (those listed in trade directories?), who should be counted as 'Glasgow artists' (those born or working elsewhere but who exhibited with the main body of Glasgow artists, as well as those born and working there?), and who should be counted as buyers of this work (only those whose collection was primarily of work by Glasgow artists?). In general, she shows that at every stage implicit aesthetic judgements were used. For example, the identification of artists was done by using the exhibition catalogues of the Glasgow Institute, which was necessarily to accept a certain selective process already completed by institutionally located mediators. As Bird says, 'The premise of aesthetic neutrality is . . . impossible to maintain, because the historical process itself assigns a value' (1979, p. 43).

A more recent study confirms this dilemma for the sociologist. Diana Crane's study of the New York art world from 1940 to 1985 (Crane, 1987) is an invaluable source of information about the art world—the dealers, critics, museums, patrons, and others—and the complex ways in which art movements are produced and succeed in these networks. However, her study is entirely dependent on a pre-existing classification of artists (into 'seven major styles', from Abstract Expressionism, via Pop and Minimalism, to Neo-Expressionism). She explains that her identification and classification of these artists was based on sources from the art world itself—major exhibitions and texts of art criticism. But this means that the exclusion of some artists cannot be explained—indeed, it cannot even be discussed. And yet the fact that her list of Abstract Expressionists contains no women, for example, is in need of explanation—precisely by sociology. Feminist art history, a crucial contribution to and revision of

the sociology of art, has raised questions about the writing-out of women from the history of art and has something to say about the omission of Lee Krasner (who was married to Jackson Pollock, and whose work has only recently been widely shown). The styles Crane investigates are the product of institutional processes, ideological preferences, and vested interests, as well as aesthetic judgements.

The sociology of art involves critical judgements about art. The solution to this, however, is not to try even harder for a value-free sociology and a more refined notion of aesthetic neutrality; it is to engage directly with the question of aesthetic value. This means, first, taking as a topic of investigation that value already bestowed on works by their contemporaries and subsequent critics and audiences. Second, it means bringing into the open those contemporary aesthetic categories and judgements which locate and inform the researcher's project. And last, it means recognising the autonomy of the question of the particular kind of pleasure involved in past and present appreciation of the works themselves. It is to the last of these requirements that many of the arguments of this book have been addressed.

The sociology of art, then, needs a theory of the aesthetic. As Bennett and others have argued, this cannot be provided by traditional 'bourgeois' aesthetics, which hypostatises universal, transhistorical, or metaphysical features of art, for those purported universal characteristics turn out on close critical scrutiny to be nothing more than the values of a particular dominant or strategically located group in society, able to project these as absolute and impartial. A sociological aesthetics can no longer be taken in by those claims. Nor can it continue to defer to the 'better' or professional judgements of art historians, critics, and philosophers of art, as Gombrich suggests (Chapter 2). In the light of the discussion in Chapter 5, I would now add that a 'materialist' aesthetics which proposes essential human characteristics is open to many of the same objections as the idealist essentialism of traditional aesthetics. Ultimately, dependence on biological constants or psychological universals is as suspect as the familiar notions of 'excellence', 'beauty', and 'life-enhanc-

ing'. It may well be that the pleasure and gratification experienced in aesthetic encounters has to be explained in terms of deep unconscious or even physical responses, but if so, these can only be conceived as historically and concretely produced in individuals in the context of the particular nature of the family in a given society and period, the specific relations between the sexes obtaining, and the wider social and ideological processes and institutions in which consciousness and experience are constructed.

Despite the difficulties involved, which I have only indicated and by no means claim to have resolved, the sociology of art must recognise and guarantee the specificity of art. The experience of it, and hence its evaluation, cannot be reduced to the totally extra-aesthetic aspects of ideology and politics, although, as we have seen, it is equally true that an aesthetic which ignores the social and political features of aesthetic judgement is unacceptable and distorted. Art has its own specificity, first, in the relatively autonomous structures, institutions, and signifying practices which constitute it, and through which it represents reality and ideology. This is simply to reassert that art is not just a reflection of the world in literary or pictorial form. But art also retains an autonomy with regard to the specifically aesthetic nature of the apprehension and enjoyment of works of art. In Chapter 5 I discussed the work of some authors who offer the beginnings of a perspective and a vocabulary in which we might analyse this specificity, and I suggested that to date the strongest contenders for this task are beset by serious weaknesses which make it difficult to see how their theoretical contributions can either solve the problem of the aesthetic or be incorporated into a sociological approach. This book has not attempted to develop or work out systematically a sociological aesthetics. My intention has been to demonstrate the need for a such a project, in light of developments in both sociology and aesthetics, and to consider sympathetically but critically some recent contributions to its progress. Discourse theory has provided us with valuable insights into the ways in which we speak about art, and the manner in which we constitute and experience it. Psychoanalytic theories of art, although

often excessively dependent on essentialist or biologistic cat-
egories, offer a good deal of promise for the understanding
of aesthetic gratification; here, recent work in the study of
popular culture suggests the possibility of a non-essentialist
approach to the exploration of desire and pleasure which are
at the root of aesthetic appeal (see, for example, Penley,
1992). But whatever the direction taken by a sociological
aesthetics, one of its most important obligations will be to
acknowledge and investigate the specific social and histori-
cal conditions of aesthetic experience and evaluation.

My original concluding sentence continued 'To that extent,
if the debate is between sociology and aesthetics, sociology
has the last word'. One of the reviewers of the book took me
up on this, in a piece entitled 'Not the last word' (Silverstone,
1983). The reviewer agrees that sociology can say much to
illuminate questions of aesthetics, and therefore 'it has the
right to many words', but resists the suggestion that sociol-
ogy somehow wins the debate. And in retrospect I agree. It
seems to me now that that formulation risks falling into the
kind of sociological imperialism I have been concerned to
avoid. Indeed, most recently certain writers, committed to a
critical and sociological aesthetics, have seemed to want to
retrieve more for the aesthetic—if not to the extent of giving
aesthetics 'the last word', then at least with the intention of
marking off an arena which is less amenable to social-his-
torical analysis than some have claimed (see Bois, 1991;
Battersby, 1991). A more radical view, proposing the discur-
sive nature of the social world, wants to concede a certain
primacy to the aesthetic—a view most dramatically articu-
lated in Lynn Hunt's statement, in the introduction to a book
of essays on cultural history, that 'History has been treated
here as a branch of aesthetics rather than as the handmaiden
of social theory' (Hunt, 1989, p. 21). In these afterthoughts
on the issues I first considered a decade ago, I want to reaf-
firm my own commitment to a sociology of art, to the social
nature of the aesthetic, and to the irreducibility of the aes-
thetic *to* the social. First I will review new work which seems
to me to support my call for a sociological aesthetic. Then I

will consider the new challenge presented to this project by the work of Hunt and others informed by poststructuralist theory, as well as by certain versions of 'postmodern' theory. Finally, I will discuss the ways in which Bois and Battersby have attempted to reassert an aesthetic beyond traditional aesthetics; this resistance to reductionism I interpret as similar to my own insistence on the specificity of the aesthetic.

The fact that aesthetic hierarchies are invariably constructed in relation to processes of social and political differentiation, already attested to by Bourdieu's studies of the class basis of taste in France, has been amply confirmed in more recent work by social historians. Lawrence Levine has examined in detail the transformation of culture in the United States during the nineteenth century. The process he describes is one of a dramatic separation of highbrow and popular cultural forms, venues, and audiences from a relatively more homogeneous culture in the early 1800s (Levine, 1988). In the 1830s, it was common to find a play by Shakespeare to be followed by an act from a melodrama, an opera performance or song recital to include popular airs, and a museum to contain curiosities, waxworks, and stuffed animals alongside paintings and sculptures. By the later part of the century, the process of 'sacralization' was complete, with a clear segregation of high and low culture. Central to this development was the formation, rise, and consolidation of a social elite, intent on marking its boundaries in terms of prestige and cultural knowledge through the differentiation and demarcation of arts institutions and practices. Although Levine has been criticised for overstating the homogeneity in the earlier period (Hall, 1990), his research clearly confirms that questions of aesthetics are implicated in extra-aesthetic processes. Paul DiMaggio's work on Boston in the same period traces the same emergence of aesthetic hierarchies, the same separation out from a once promiscuous mix of genres and audiences into two distinct cultural worlds (DiMaggio, 1982). DiMaggio, employing Bourdieu's notion of 'cultural capital', more explicitly identifies this as a class-related process, in which the dominant group confirms its social and eco-

nomic power in the field of culture, creating an exclusionary realm which reinforces social divisions. (See also Seed and Wolff, 1984).

Feminist historians of art have provided evidence that gender issues intrude into ostensibly aesthetic judgements. Rozsika Parker's social history of embroidery explains how a practice which was once a high-prestige activity undertaken by men became increasingly associated with women and domesticity by the eighteenth century, and accordingly became separated from the other arts and downgraded to an amateur pastime (Parker, 1984). An interesting reverse process seems to be operating in the late twentieth century, whereby the transformation of *craft* into 'art' has been accompanied by the increased visibility and success of men in areas which until recently were more solidly female. These new aspirations are promoted by crafts institutions, galleries, journals, and art-educational practices and ideologies (and, of course, they are both motivated and consolidated by enormous increases in the value and price of art-craft). Although the causal relationship is unclear (that is, whether it is the influx of men which increases aesthetic value, or the other way round), the visible presence of successful male potters and textile and jewelry workers is worth remarking. The phenomenon replays one from a hundred years ago, noted by Gaye Tuchman and Nina Fortin, who examined the records of the London publisher, Macmillan, and discovered that as the novel gained in prestige, women were gradually 'edged out' (Tuchman and Fortin, 1989).

Postcolonial criticism challenges traditional aesthetics on a number of grounds. First, critical analysis of literature and the visual arts in the West has exposed ethnocentric ideologies at work in the text, and it is no longer possible to discuss such works in purely aesthetic terms. Primary among such ideologies since the nineteenth century have been *orientalism* and *primitivism* as themes in written and painted texts. (see Said, 1978; Nochlin, 1989; Hiller, 1991). In addition, the presentation in the West of works from other cultures has historically and persistently constructed those cultures in racist and ethnocentric terms (for example, in

ethnographic exhibits clearly based on an evolutionary view of 'primitive' and 'advanced' cultures). At the same time, the display of 'treasures' from non-Western societies has systematically obscured the colonial relations of oppression and expropriation which lie behind the transfer of those objects to museums. (see Clifford, 1988; Karp and Lavine, 1991). Finally, the work of minority artists and writers in the West continues to be marginalised and ignored, since the dominant 'aesthetic' standards ('quality' and 'excellence'—often employed intuitively) automatically disqualify work founded on different traditions and principles. In general, the aesthetic here is further deconstructed by recent work in this field.

With regard to the growing number of critical studies in the arts, one could add the fact that even musicology—that most 'transcendent' of the arts—has come under the investigation of scholars concerned to demonstrate the class, gender, and race issues at play in the musical text. (see Leppert and McClary, 1987; McClary, 1986, 1991; Locke, 1992). But by now I think it is no longer necessary to document the claim that there is nothing 'pure' about art. In addition to the rereadings of texts (visual, literary, or musical) themselves, reception studies confirm the fact by refusing the notion of any single, fixed meaning of a text. The instability of meaning, and the provisional nature of interpretation (dependent as it always is on particular audiences/readers/viewers and their specific situations) have become commonplace both in literary analysis and in media studies. What follows for aesthetics is the difficulty of arguing for a fixed vantage-point for evaluation, as well as interpretation.

The weight of evidence here seems to be 'on the side' of sociology. But I want to consider an important argument against the excesses of this conclusion. In another review of the first edition of this book, Tony Hincks followed through the logic of my argument to the conclusion that sociology itself, like the aesthetic, is a discourse (Hincks, 1984). As he rightly points out, the critique of ideology applies equally to sociological knowledge, which is not exempt from the critical analysis of its assumptions and practices. He is right, too, to insist on the discursive nature of sociology (and hence of

its intervention into the field of aesthetics). The question is whether it follows from this that there is no basis for proposing the 'real' structures and relations of the social world in terms of which I have wanted to examine the aesthetic. This has been an issue much contested in cultural studies in recent years. An influential school of thought, based on varieties of poststructuralist theory, maintains that we cannot sustain a belief in the real, or a commitment to the 'metanarratives' of historical explanation (like Marxism). Lynn Hunt's statement, which I quoted earlier, is an example of what has become a common view in postmodern thought and among some scholars working in the 'new' fields of the humanities (the new historicism, the new art history, the new cultural history: see Veeser, 1989; Rees and Borzello, 1986; and Hunt, 1989, respectively). In my view, this tendency produces a new idealism which is neither acceptable nor necessary. It does not follow from the recognition that all institutions and practices are discursively mediated that we cannot identify persistent structures and their effectivities in the social world. Although this is not the place to take up a complex, and unresolved, debate, I simply align myself here with those who refuse to accept that we can only talk about 'class' rather than class, or that we have no access to 'the real'. (see Hunter, 1988; Aronowitz, 1986/7; Mouzelis, 1988). While recognising that histories are always discursively produced (and hence partial accounts), we can still insist that some accounts are better than others. It follows from this that although sociology, too, has historically been and continues to be the product of certain interests, and although as a practice it operates as a discourse, we can still look for the grounding of (aesthetic) discourse in the social.

I referred in the Introduction to the transformation of 'cultural studies' on its travels from Britain to the United States. (On this, see also Nelson, 1991.) In America, at least one influential version of cultural studies, mainly practised within departments of literary studies, consists primarily of the critical readings of texts on the basis of semiotics and psychoanalysis. It is not difficult to discover the institutional and intellectual origins of this development, the former being the

literary (rather than social-scientific) basis of the work, and the latter being a direct product of that poststructuralist philosophy I have been discussing. In other words, commitment to a fundamentally discursive view of the world can result in the belief that *everything* is a text—including social relations and institutions. Indeed, this formulation is quite common in literary studies at the moment. (And Lynn Hunt argues that the new cultural history 'has to establish the objects of historical study as being like those of literature and art': Hunt 1989, p. 17.) Whatever the reason for this tendency, my argument against it is that in 'textualising' the social and the historical it evacuates that very arena and, by the same move, abandons the possibility of a sociology of culture and art.

Related to this is the view current among postmodern theorists that we have achieved a new eclecticism and at least the beginnings of the breakdown of cultural hierarchies, at a time when high culture and popular culture quote one another, when avant-garde artists like Philip Glass and Laurie Anderson are at the same time popular and accessible, and when a general eclecticism and egalitarianism seem to characterise the cultural arena (see Collins, 1989, for one such view). The demise of metanarratives, identified (and celebrated) by postmodern philosophy, is paralleled by the deconstruction of aesthetic (and, it is often implied, social) categories in postmodern cultural practices. There is a continuing debate about the progressive potential (or otherwise) of so-called postmodern art, initiated by the essays in Hal Foster's 1983 edited collection, *The Anti-Aesthetic*. Here, I simply want to argue against the more radical claims for the possibilities of the postmodern. The correct perception of increased eclecticism, of the plundering of mass culture by Art, and of the quoting of Art by mass culture, does not mean that there is no organising principle behind this confusion, or that culture no longer serves certain clear social interests (of class or gender, for example). What seems to me to be lacking in these celebrations of the postmodern (theory or cultural practice) is an adequate *sociology* of knowledge, which locates the emergence of the postmodern and examines critically the structural features in which it is integrated.

Poststructuralism and postmodern theory, I am suggesting, at best abandon or circumvent the task of a sociological aesthetics; at worst, they collude with conservative thought in its negation. More persuasive have been those attempts to retrieve the aesthetic in the context of a sociological and critical perspective. Yve-Alain Bois, speaking about 'resisting the blackmail' of fashion and theoreticism, has argued for a new formalism in the study of the visual arts, which, without abandoning ideological critique or social history, enables the art critic to pay attention to the structural features and content of works (Bois, 1991). In the context of feminist art criticism, Christine Battersby (1991) defends the reinstatement of the aesthetic as central in culture, against those tendencies which have colluded to dismiss evaluative criticism. It seems now that at least in some circles a somewhat over-enthusiastic leap into critical studies, and away from the object, is being remedied by a new attempt to combine critical thought (by which I mean a social-historical perspective on textual analysis) with respect for the object, acknowledgement of the relative autonomy of the aesthetic sphere and its practices and languages, and a commitment to careful readings. This project, as the editors of a recent book have said about the essays in the volume, would be 'part of an attempt to think art beyond the bounds of traditional aesthetics. Beyond traditional aesthetics—beyond the aesthetics of tradition—but not thereby necessarily beyond aesthetics' (Benjamin and Osborne, 1991). Perhaps no one (sociologists included) has the last word. And perhaps, in the end, the very formulation of the problem as an opposition between two approaches and two disciplines turns out to be misleading. In any case, aesthetics cannot be unaffected by sociology—nor sociology dismissive of the aesthetic.

Bibliography

Althusser, L. (1971a), 'Cremonini, painter of the abstract', in his *Lenin and Philosophy and Other Essays* (London: New Left Books), pp. 209–20.

Althusser, L. (1971b), 'A letter on art in reply to André Daspre', in his *Lenin and Philosophy and Other Essays* (London: New Left Books), pp. 203–8.

Aronowitz, Stanley (1986/7), 'Theory and socialist strategy', *Social Text,* vol. 16, pp. 1–16.

Arts Council of Great Britain (1978), *Gustave Courbet 1819–1877* (London: Arts Council).

Aufderheide, Patricia, ed. (1992), *Beyond P.C.: Toward a Politics of Understanding* (St. Paul, Minn.: Graywolf Press).

Barnett, James H. (1959), 'The sociology of art', in *Sociology Today,* Vol. I, ed. Robert K. Merton, Leonard Broom and Leonard S. Cottrell, Jr (New York: Harper & Row), pp. 197–214.

Barrett, Michèle, and Radford, Jean (1979), 'Modernism in the 1930s: Dorothy Richardson and Virginia Woolf', in *1936: The Sociology of Literature: Vol. I, The Politics of Modernism* (Essex: University of Essex), pp. 252–72.

Battersby, Christine (1991), 'Situating the aesthetic: a feminist defence', in *Thinking Art: Beyond Traditional Aesthetics,* ed. Andrew Benjamin and Peter Osborne (London: Institute of Contemporary Arts), pp. 31–43.

Becker, Oskar (1962), 'Die Fragwürdigkeit der Transzendierung der ästhetischen Dimension der Kunst', *Philosophische Rundschau,* vol. 10, pp. 225–38.

Bell, Clive (1958), *Art* (New York: Capricorn Books).

Bellah, R. (1970), *Beyond Belief* (New York: Harper).

Benjamin, Andrew, and Osborne, Peter, eds. (1991), *Thinking Art: Beyond Traditional Aesthetics* (London: Institute of Contemporary Arts).

Benjamin, Walter (1973a), 'The author as producer', in Benjamin, 1973b, pp. 85–103.

Benjamin, Walter (1973b), *Understanding Brecht* (London: New Left Books).

Bennett, Tony (1979), *Formalism and Marxism* (London: Methuen).

Bensman, J., and Lilienfeld, R. (1968), 'A phenomenological model of the artistic and critical attitudes', *Philosophy and Phenomenological Research,* vol. 28, pp. 353–67.

Berger, John (1972), *Ways of Seeing* (Harmondsworth: Penguin).

Berman, Paul, ed. (1992), *Debating P.C.: The Controversy over Political Correctness on College Campuses* (New York: Dell Publishing).

Bernstein, Richard J. (1978), *The Restructuring of Social and Political Theory* (Philadelphia, Pa: University of Pennsylvania Press).

117

Bird, Elizabeth (1979), 'Aesthetic neutrality and the sociology of art', in *Ideology and Cultural Production*, ed. Michèle Barrett, Philip Corrigan, Annette Kuhn and Janet Wolff (London: Croom Helm), pp. 25–48.

Bois, Yve-Alain (1991), *Painting as Model* (Cambridge, Mass.: MIT Press).

Bolton, Richard, ed. (1992), *Culture Wars: Documents from the Recent Controversies in the Arts* (New York: New Press).

Bourdieu, Pierre (1979), *La Distinction: critique sociale du jugement* (Paris: Editions de Minuit).

Bourdieu, Pierre (1980), 'The aristocracy of culture', *Media, Culture and Society*, vol. 2, no. 3, pp. 225–54.

Brecht, Bertolt (1964), 'A short organum for the theatre', in *Brecht on Theatre. The Development of an Aesthetic*, ed. John Willett (London: Eyre Methuen), pp. 179–205.

Brighton, Andrew (1977), 'Official art and the Tate Gallery', *Studio International*, vol. 193, no. 985, pp. 41–4.

Brighton, Andrew, and Morris, Lynda, eds. (1977), *Towards Another Picture* (Nottingham: Midland Group).

Burger, Peter (1984), *Theory of the Avant-Garde* (Minneapolis: University of Minnesota Press).

Caute, David (1974), 'A portrait of the artist as midwife: Lucien Goldmann and the "transindividual subject" ', in *Collisions: Essays and Reviews* (London: Quartet), pp. 219–27.

Clark, T. J. (1973), *Image of the People: Gustave Courbet and the 1848 Revolution* (London: Thames & Hudson).

Clark, T. J. (1974), 'The conditions of artistic creation', *Times Literary Supplement*, 24 May, pp. 561–2.

Clifford, James (1988), 'Histories of the tribal and the modern', in his *The Predicament of Culture. Twentieth-Century Ethnography, Literature, and Art* (Cambridge, Mass.: Harvard University Press), pp. 189–214.

Collingwood, R. G. (1963), *The Principles of Art* (London: OUP).

Collins, Jim (1989), *Uncommon Cultures: Popular Culture and Post-Modernism* (New York: Routledge).

Coward, Ros, Lipshitz, Sue, and Cowie, Elizabeth (1976), 'Psychoanalysis and patriarchal structures', in *Papers on Patriarchy*, ed. Sue Cooper, Sara Crowley and Charlotte Holtam (Sussex: Women's Publishing Collective), pp. 6–20.

Craig, Sandy (1979), 'The ways of the arts establishment are paved with good intentions', *Time Out*, 30 November, pp. 14–17.

Crane, Diana (1987), *The Transformation of the Avant-Garde: The New York Art World, 1940–1985* (Chicago: University of Chicago Press).

Daley, Janet (1980/1), 'Cliques and coteries and the visual arts', *New Universities Quarterly*, vol. 35, no. 1, pp. 57–65.

Davies, Tony (1978), 'Education, ideology and literature', *Red Letters*, no. 7, pp. 4–15.

Della Volpe, Galvano (1978), *Critique of Taste* (London: New Left Books).

Derrida, Jacques (1987), *The Truth in Painting* (Chicago: University of Chicago Press).

Dickie, George (1969), 'The myth of the aesthetic attitude', in *Introductory Readings in Aesthetics*, ed. John Hospers (London: Collier Macmillan), pp. 28–44.

DiMaggio, Paul (1982), 'Cultural entrepreneurship in nineteenth-century Boston: the creation of an organizational base for high culture in America', *Media, Culture and Society*, vol. 4, no. 1, pp. 33–50.

Douglas, Mary (1981), 'High culture and low', *Times Literary Supplement*, 13 February, pp. 163–4.

Dufrenne, Mikel (1953), *Phénoménologie de l'expérience esthétique*, 2 vols (Paris: Presses Universitaires de France).

Eagleton, Terry (1976), *Criticism and Ideology* (London: New Left Books).

Eagleton, Terry (1978a), '"Aesthetics and politics"', *New Left Review*, no. 107, pp. 21–34.

Eagleton, Terry (1978b), 'Liberality and order: the criticism of John Bayley', *New Left Review*, no. 110, pp. 29–40.

Eagleton, Terry (1978c), 'Tennyson: politics and sexuality in *The Princess* and *In Memoriam*', in *1848: The Sociology of Literature*, ed. Francis Barker, John Coombes, Peter Hulme, Colin Mercer and David Musselwhite (Essex: University of Essex), pp. 97–106.

Eagleton, Terry (1981), *Walter Benjamin, or Towards a Revolutionary Criticism* (London: New Left Books).

Eagleton, Terry (1990), *The Ideology of the Aesthetic* (Oxford: Basil Blackwell).

Ehrmann, Jacques, ed. (1970), *Literature and Revolution* (Boston, Mass.: Beacon Press).

Elliott, R. K. (1972), 'Aesthetic theory and the experience of art', in *Aesthetics*, ed. Harold Osborne (London: OUP), pp. 145–57.

Felski, Rita (1989), *Beyond Feminist Aesthetics: Feminist Literature and Social Change* (Cambridge, Mass.: Harvard University Press).

Foster, Hal, ed. (1983), *The Anti-Aesthetic: Essays on Postmodern Culture* (Port Townsend, Wash.: Bay Press).

Foucault, Michel (1972), *The Archaeology of Knowledge* (London: Tavistock).

Foucault, Michel (1973), *The Birth of the Clinic* (London: Tavistock).

Foucault, Michel (1977), *Discipline and Punish: The Birth of the Prison* (London: Allen Lane).

Foucault, Michel (1979a), *The History of Sexuality. Vol. I: An Introduction* (London: Allen Lane).

Foucault, Michel (1979b), 'What is an author?', *Screen*, vol. 20, no. 1, pp. 13–29. (Originally published 1969.)

Foucault, Michel (1980a), introduction to *Herculine Barbin: Being the Recently Discovered Memoirs of a Nineteenth-Century French Her-*

maphrodite (Brighton: Harvester Press), pp. vii–xvii.

Foucault, Michel (1980b), *Power/Knowledge: Selected Interviews and Other Writings 1972–1977*, ed. Colin Gordon (Brighton: Harvester Press).

Fuller, Peter (1980a), *Art and Psychoanalysis* (London: Writers and Readers Publishing Co-operative).

Fuller, Peter (1980b), *Beyond the Crisis in Art* (London: Writers and Readers Publishing Co-operative).

Fuller, Peter (1980c), *Seeing Berger: A Revaluation* (London: Writers and Readers Publishing Co-operative).

Gadamer, Hans-Georg (1975), *Truth and Method* (London: Sheed & Ward). (Originally published 1960.)

Gadamer, Hans-Georg (1976), 'Aesthetics and hermeneutics', in his *Philosophical Hermeneutics* (London: University of California Press), pp. 95–104. (Originally published 1964.)

Garnham, Nicholas, and Williams, Raymond (1980), 'Pierre Bourdieu and the sociology of culture: an introduction', *Media, Culture and Society*, vol. 2, no. 3, pp. 209–23.

Giddens, Anthony (1977a), 'Habermas's critique of hermeneutics', in his *Studies in Social and Political Theory* (London: Hutchinson), pp. 135–64.

Giddens, Anthony (1977b), 'Max Weber on facts and values', in his *Studies in Social and Political Theory* (London: Hutchinson), pp. 89–95.

Goldmann, Lucien (1964), *The Hidden God: A Study of Tragic Vision in the 'Pensées' of Pascal and the Tragedies of Racine* (London: Routledge & Kegan Paul). (Originally published 1955.)

Gombrich, E. H. (1960), *Art and Illusion: A Study in the Psychology of Pictorial Representation* (London: Phaidon).

Gombrich, E. H. (1965), 'The social history of art', in his *Meditations on a Hobby Horse and Other Essays* (London: Phaidon), pp. 86–94. (Originally published 1953.)

Gombrich, E. H. (1975), *Art History and the Social Sciences* (London: OUP).

Goodman, Nelson (1976), *Languages of Art: An Approach to a Theory of Symbols* (Indianapolis, Ind.: Hackett).

Gray, Camilla (1971), *The Russian Experiment in Art 1863–1922* (London: Thames & Hudson).

Greer, Germaine (1979), *The Obstacle Race: The Fortunes of Women Painters and Their Work* (London: Secker & Warburg).

Habermas, Jürgen (1970a), 'Knowledge and interest', in *Sociological Theory and Philosophical Analysis*, ed. Dorothy Emmet and Alasdair MacIntyre (London: Macmillan), pp. 36–54. (First English edition 1966.)

Habermas, Jürgen (1970b), 'Technology and science as "ideology"', in his *Toward a Rational Society: Student Protest, Science, and Politics* (Boston, Mass.: Beacon Press), pp. 81–122.

Hadjinicolaou, Nicos (1978a), *Art History and Class Struggle* (London: Pluto).

Hadjinicolaou, Nicos (1978b), 'Art history and the history of the appreciation of works of art', *Proceedings of the Caucus for Marxism and Art at the College Art Association Convention, January 1978* (Los Angeles, Calif.: Caucus for Marxism and Art), pp. 9–12.

Hall, David D. (1990), 'A world turned upside down?', *Reviews in American History*, vol. 18, no. 1 (March), pp. 10–14.

Hall, Stuart (1980), 'Cultural studies and the Centre: some problematics and problems', in *Culture, Media, Language: Working Papers in Cultural Studies, 1972–79*, ed. Stuart Hall, Dorothy Hobson, Andrew Lowe and Paul Willis (London: Hutchinson), pp. 15–47.

Haskell, Francis (1976), *Rediscoveries in Art: Some Aspects of Taste, Fashion and Collecting in England and France* (Oxford: Phaidon).

Hauser, Arnold (1968), *The Social History of Art*, vol. 2 (London: Routledge & Kegan Paul). (First English edition 1951.)

Hawthorn, J. M. (1973), *Identity and Relationship: A Contribution to Marxist Theory of Literary Criticism* (London: Lawrence & Wishart).

Heath, Stephen (1978), 'Difference', *Screen*, vol. 19, no. 3, pp. 51–112.

Held, David (1980), *Introduction to Critical Theory: Horkheimer to Habermas* (London: Hutchinson).

Hess, Hans (1975), *Pictures as Arguments* (London: Chatto & Windus for Sussex University Press).

Hess, Thomas B. (1973), 'Great women artists', in *Art and Sexual Politics*, ed. Thomas B. Hess and Elizabeth C. Baker (London: Collier Macmillan), pp. 44–8.

Hesse, Mary (1974), 'In defence of objectivity', *Proceedings of the British Academy, vol. LVIII, 1972* (London: OUP), pp. 275–92.

Hiller, Susan, ed. (1991), *The Myth of Primitivism: Perspectives on Art* (London: Routledge).

Hincks, Tony (1984), 'Aesthetics and the sociology of art: a critical commentary on the writings of Janet Wolff', *British Journal of Aesthetics*, vol. 24, no. 4 (Autumn), pp. 341–54.

Hockney, David (1979), 'No joy at the Tate', *Observer*, 4 March, pp. 33–4.

Hoggart, Richard (1980/1), 'The crisis of relativism', *New Universities Quarterly*, vol. 35, no. 1, pp. 21–32.

Holbrook, David (1980/1), 'The arts and the need for meaning', *New Universities Quarterly*, vol. 35, no. 1, pp. 89–109.

Hospers, John, ed. (1969), *Introductory Readings in Aesthetics* (London: Collier Macmillan).

Howe, Irving (1970), *Politics and the Novel* (New York: Avon Books).

Hungerland, Isabel Creed (1972), 'Once again, aesthetic and non-aesthetic', in *Aesthetics*, ed. Harold Osborne (London: OUP), pp. 106–20.

Hunt, Lynn (1989), *The New Cultural History* (Berkeley and Los Angeles: University of California Press).

Hunter, Allen (1988), 'Post-Marxism and the new social movements', *Theory and Society*, vol. 17, pp. 885–900.

Ingarden, Roman (1931), *Das Literarische Kunstwerk* (Tübingen: Niemeyer).

Ingarden, Roman (1972), 'Artistic and aesthetic values', in *Aesthetics*, ed. Harold Osborne (London: OUP), pp. 39–54.

Jauss, Hans Robert (1970), 'Literary history as a challenge to literary theory', *New Literary History*, vol. II, no. 1, pp. 7–37.

Kant, Immanuel (1952), *The Critique of Judgement* (Oxford: OUP). (Original German edition 1790.)

Kaplan, Cora (1976), 'Language and gender', in *Papers on Patriarchy*, ed. Sue Cooper, Sara Crowley and Charlotte Holtam (Sussex: Women's Publishing Collective), pp. 21–37.

Karp, Ivan, and Lavine, Steven D., eds. (1991), *Exhibiting Cultures: The Poetics and Politics of Museum Display* (Washington, D.C.: Smithsonian Institution Press).

Keat, Russell (1981), *The Politics of Social Theory: Habermas, Freud and the Critique of Positivism* (Oxford: Blackwell).

Khan, Naseem (1976), *The Arts Britain Ignores: The Arts of Ethnic Minorities in Britain* (London: Commission for Racial Equality).

Khan, Naseem (1981), 'Britain's new arts', *Journal of Aesthetic Education*, vol. 15, no. 3, pp. 59–65.

Királyfalvi, Béla (1975), *The Aesthetics of György Lukács* (London: Princeton University Press).

Klingender, Francis D. (1972), *Art and the Industrial Revolution* (London: Paladin).

Laclau, Ernesto (1980), 'Populist rupture and discourse', *Screen Education*, no. 34, pp. 87–93.

Langer, Susanne K. (1962), *Philosophical Sketches* (Baltimore, Md.: Johns Hopkins University Press).

Lenin, V. I. (1970), 'Party organisation and party literature', in his *On Literature and Art* (Moscow: Progress Publishers), pp. 22–7.

Leppert, Richard, and McClary, Susan, eds. (1987), *Music and Society: The Politics of Composition, Performance and Reception* (Cambridge: Cambridge University Press).

Levine, Lawrence W. (1988), *Highbrow/Lowbrow: The Emergence of Cultural Hierarchy in America* (Cambridge, Mass.: Harvard University Press).

Lichtheim, George (1970), *Lukács* (London: Fontana/Collins).

Locke, Ralph P. (1992), 'Constructing the Oriental "Other": Saint-Saens's *Samson et Dalila*', *Cambridge Opera Journal*, vol. 3, no. 3, pp. 261–302.

Lovell, Terry (1978), 'Jane Austen and the gentry: a study in literature and ideology', in *The Sociology of Literature: Applied Studies*, ed. Diana Laurenson, Sociological Review Monograph No. 26 (Keele: University of Keele), pp. 15–37. Also in *Literature, Society and the Sociology of Literature*, ed. Francis Barker *et al.* (Essex: University of Essex), pp. 118–32.

Lovell, Terry (1980), *Pictures of Reality: Aesthetics, Politics and Pleasure* (London: British Film Institute).

Lukács, Georg (1963), *Die Eigenart des Ästhetischen*, 2 vols (Neuweid and Berlin: Luchterhand).

Lukács, Georg (1969), 'Über die Besonderheit als Kategorie der Ästhetik', in *Probleme der Ästhetik, Georg Lukács Werke, vol. 10* (Neuwied and Berlin: Luchterhand), pp. 537–786.

Lukács, Georg (1970), 'Narrate or describe?', in his *Writer and Critic and Other Essays* (London: Merlin Press), pp. 110–48.

Lukács, Georg (1971a), *History and Class Consciousness* (London: Merlin Press). Originally published as *Geschichte und Klassenbewusstsein* (Berlin: Malik, 1923).

Lukács, Georg (1971b), *The Theory of the Novel* (London: Merlin Press).

Lukács, Georg (1974), *Soul and Form* (London: Merlin Press).

Lukács, Georg (1980), *The Destruction of Reason* (London: Merlin Press).

MacCabe, Colin (1975), 'Presentation of "The imaginary signifier"', *Screen*, vol. 16, no. 2, pp. 7–13.

MacCabe, Colin (1976), 'Principles of realism and pleasure', *Screen*, vol. 17, no. 3, pp. 7–27.

MacCabe, Colin (1978), *James Joyce and the Revolution of the Word* (London: Macmillan).

McClary, Susan (1986), 'A musical dialectic from the Enlightenment: Mozart's *Piano Concerto in G Major, K.453,* movement 2', *Cultural Critique*, no. 4 (Fall), pp. 129–69.

McClary, Susan (1991), *Feminine Endings: Music, Gender, and Sexuality* (Minneapolis: University of Minnesota Press).

McDonnell, Kevin, and Robins, Kevin (1980), 'Marxist cultural theory: the Althusserian smokescreen', in *One-Dimensional Marxism: Althusser and the Politics of Culture*, ed. Simon Clarke, Terry Lovell, Kevin McDonnell, Kevin Robins and Victor Jeleniewski Siedler (London: Allison & Busby), pp. 157–231.

McGuigan, Jim (1981), *Writers and the Arts Council* (London: Arts Council).

Marcuse, Herbert (1964), *One Dimensional Man* (London: Routledge & Kegan Paul).

Marcuse, Herbert (1968), 'The affirmative character of culture', in his *Negations: Essays in Critical Theory* (London: Allen Lane), pp. 88–133.

Marcuse, Herbert (1969a), *Eros and Civilisation* (London: Sphere).

Marcuse, Herbert (1969b), *An Essay on Liberation* (Boston, Mass.: Beacon Press).

Marcuse, Herbert (1978), *The Aesthetic Dimension: Toward a Critique of Marxist Aesthetics* (Boston, Mass.: Beacon Press).

Marxist-Feminist Literature Collective (1978), 'Women's Writing: *Jane Eyre, Shirley, Villette, Aurora Leigh*', *Ideology and Consciousness*, no. 3, pp. 27–48. Also in *1848: The Sociology of Literature*, ed.

Francis Barker *et al.* (Essex: University of Essex), pp. 185–206.
Mercer, Colin (1980), 'After Gramsci', *Screen Education*, no. 36, pp. 5–15.
Metz, Christian (1975), 'The imaginary signifier', *Screen*, vol. 16, no. 2, pp. 14–76.
Morawski, Stefan (1974), *Inquiries into the Fundamentals of Aesthetics* (Cambridge, Mass., and London: MIT Press).
Mouzelis, Nicos (1988), 'Marxism or Post-Marxism?', *New Left Review,* no. 167, pp. 107–23.
Mulhern, Francis (1979), *The Moment of 'Scrutiny'* (London: New Left Books).
Mulkay, Michael (1979), *Science and the Sociology of Knowledge* (London: Allen & Unwin).
Natanson, Maurice (1962), *Literature, Philosophy and the Social Sciences: Essays in Existentialism and Phenomenology* (The Hague: Nijhoff), pt II: 'Aesthetics and Literature', pp. 77–152.
Nelson, Cary (1991), 'Always already cultural studies: two conferences and a manifesto', *Journal of the Midwest Modern Language Association,* vol. 24, no. 1 (Spring), pp. 24–38.
Nochlin, Linda (1973), 'Why have there been no great women artists?', in *Art and Sexual Politics*, ed. Thomas B. Hess and Elizabeth C. Baker (London: Collier Macmillan), pp. 1–39.
Nochlin, Linda (1989), 'The imaginary Orient', in her *The Politics of Vision: Essays on 19th Century Art and Society* (New York: Harper & Row), pp. 33–59.
Osborne, Harold (1972), *Aesthetics* (London: OUP).
Parker, Rozsika (1984), *The Subversive Stitch: Embroidery and the Making of the Feminine* (London: Women's Press).
Parker, Rozsika, and Pollock, Griselda (1981), *Old Mistresses: Women, Art and Ideology* (London: Routledge & Kegan Paul).
Parsons, Talcott (1951), *The Social System* (London: Routledge & Kegan Paul).
Pearson, Nicholas (1979), 'The Arts Council of Great Britain', *New Arts* (Hebden Bridge, West Yorkshire) no. 2, pp. 5, 17–20.
Penley, Constance (1992), 'Feminism, psychoanalysis, and the study of popular culture', in *Cultural Studies,* ed. Lawrence Grossberg, Cary Nelson and Paula Treichler (New York: Routledge), pp. 479–94.
Podro, Michael (1972), *The Manifold in Perception: Theories of Art from Kant to Hildebrand* (London: OUP).
Pollock, Griselda (1979), 'Feminism, femininity and the Hayward Annual Exhibition 1978', *Feminist Review*, no. 2, pp. 33–55.
Pollock, Griselda (1980), 'Artists, mythologies and media – genius, madness and art history', *Screen*, vol. 21, no. 3, pp. 57–96.
Raphael, Max (1979), *Proudhon, Marx, Picasso: Three Studies in the Sociology of Art* (London: Lawrence & Wishart). (Original French edition 1933.)
Rees, A. L., and Borzello, F., eds. (1986), *The New Art History* (London: Camden Press).

Reid, Sir Norman (1979), 'Buying the best', (reply to David Hockney), *Observer*, 11 March, pp. 33, 35.

Royal Academy of Arts (1979), *Post-Impressionism* (London: RAA).

Rühle, Jürgen (1969), *Literature and Revolution* (London: Pall Mall Press).

Said, Edward W. (1978), *Orientalism* (London: Routledge & Kegan Paul).

Scharf, Aaron (1972), *Art and Politics in France. The Age of Revolutions* (Milton Keynes: Open University Press).

Schutz, Alfred (1967a), 'On multiple realities', in his *Collected Papers*, Vol. I (The Hague: Nijhoff), pp. 207–59.

Schutz, Alfred (1967b), 'Symbol, reality and society', in his *Collected Papers*, Vol. I (The Hague: Nijhoff), pp. 287–356.

Scruton, Roger (1974), *Art and Imagination* (London: Methuen).

Seed, John, and Wolff, Janet, (1984), 'Class and culture in 19th century Manchester', *Theory, Culture & Society*, vol. 2, no. 2, pp. 38–53.

Shaw, Sir Roy (1980/1), 'Problems of evaluation', *New Universities Quarterly*, vol. 35, no. 1, pp. 33–6.

Shaw, Sir Roy (1981), 'The Arts Council and aesthetic education', *Journal of Aesthetic Education*, vol. 15, no. 3, pp. 85–92.

Silverstone, Roger (1983), 'Not the last word', *Times Higher Education Supplement*, 15 April.

Sutcliffe, Tom (1981), 'Has the Arts Council outlived its usefulness?', *Guardian*, 27 January, p. 9.

Tagg, John (1980), 'The method of criticism and its objects in Max Raphael's theory of art', *Block*, no. 2, pp. 2–14.

Taylor, Roger L. (1978), *Art, an Enemy of the People* (Brighton: Harvester Press).

Timpanaro, Sebastiano (1975), *On Materialism* (London: New Left Books).

Todd, Jennifer (1981), 'Georg Lukács, Walter Benjamin, and the motivation to make political art', *Radical Philosophy*, no. 28, pp. 16–22.

Tuchman, Gaye, with Nina E. Fortin (1989), *Edging Women Out: Victorian Novelists, Publishers, and Social Change* (New Haven: Yale University Press).

Veeser, A. Aram, ed. (1989), *The New Historicism* (New York: Routledge).

Wallach, Alan, and Duncan, Carol (1978), 'Ritual and ideology at the museum', *Proceedings of the Caucus for Marxism and Art at the College Art Association Convention, January 1978* (Los Angeles, Calif.: Caucus for Marxism and Art), pp. 30–1.

Watts, Janet (1980), 'Patronage behind closed doors', *Observer*, 2 March, p. 37.

Watts, Janet (1981), 'The Star Chamber?', *Observer*, 15 March, p. 34.

Weber, William (1975), *Music and the Middle Class: The Social Structure of Concert Life in London, Paris and Vienna* (London: Croom Helm).

Weedon, Chris, Tolson, Andrew, and Mort, Frank (1980), 'Theories of language and subjectivity', in *Culture, Media, Language: Working Papers in Cultural Studies, 1972–9*, ed. Stuart Hall, Dorothy Hobson,

Andrew Lowe and Paul Willis (London: Hutchinson), pp. 195–216.

Williams, Raymond (1965), *The Long Revolution* (Harmondsworth: Penguin).

Williams, Raymond (1977), *Marxism and Literature* (Oxford: OUP).

Williams, Raymond (1979), *Politics and Letters: Interviews with 'New Left Review'* (London: New Left Books).

Williams, Raymond (1980), 'Problems of materialism', in his *Problems in Materialism and Culture* (London: New Left Books), pp. 103–22. (Originally published in *New Left Review*, no. 109, 1978.)

Williams, Raymond (1981), *Culture* (Glasgow: Fontana/Collins).

Wilson, Elizabeth (1981), 'Psychoanalysis: psychic law and order', *Feminist Review*, no. 8, pp. 63–78.

Wittgenstein, L. (1967), *Lectures and Conversations on Aesthetics, Psychology and Religious Belief* (Berkeley and Los Angeles: University of California Press).

Wolff, Janet (1981), *The Social Production of Art* (London: Macmillan).

Wolff, Janet (1992), 'Against sociological imperialism: the limits of sociology in the aesthetic sphere', in *The Analysis of Change in Aesthetic and Art Education,* ed. Ronald W. Neperud (Teachers College Press).

Wollheim, Richard (1970), 'Sociological explanation of the arts: some distinctions', in *The Sociology of Art and Literature*, ed. Milton C. Albrecht, James H. Barnett and Mason Griff (London: Duckworth), pp. 574–81.

Wollheim, Richard (1980), *Art and its Objects* (Cambridge: CUP). (Originally published 1968.)

Index

Aesthetic attitude, aesthetic disposition 12, 18, 19–20, 36, 47 73–7, 79; aesthetic experience 12, 21, 27, 29, 30, 31, 35, 43, 60, 67, 68, 72, 73, 74, 79, 105, 107; aesthetic judgement 11, 12, 17, 19, 20, 27, 28, 29, 30, 32, 34, 38, 44, 60, 62, 65, 106; aesthetic value, aesthetic evaluation 11, 14, 17, 20, 21, 22, 26, 28, 31, 32, 33, 34, 35, 44, 45, 46, 48, 49, 50, 58, 59, 62, 65, 67, 68, 72, 76, 79, 90, 95, 105, 106, 107; popular aesthetic 20, 36–7; sociological aesthetics 14, 26, 44, 46, 68, 77, 80, 90, 105–8; sociological critique of aesthetics 11–26, 27, 31, 37, 38, 48; Soviet aesthetics 22; aesthetic neutrality 106; aesthetic ideology 24

Althusser, L. 38, 44–6, 57–8
André, C. 48
Art as ideology 23, 31, 44; abstract art, non-representational art, non-figurative art 23, 24, 48, 66; Greek art 23; history of art 12, 16, 18, 23, 28–9, 31, 83, 93, 105, 107; nineteenth-century art 18; phenomenology of art 18, 73–8, 79, 80, 82; philosophy of art 11, 12, 14, 27–8, 68–84, 107; art and politics 62–7; psychology of art 30–1; social history of art 11, 13, 14, 15–16, 21, 22, 27, 28, 65; specificity of art 12, 21, 22, 26, 31, 32, 37, 38, 42, 45, 46, 68, 82, 83–4, 85–104, 107–8
Artist 13, 23, 31, 62, 71, 93, 106

Arts Council of Great Britain 49, 50, 66
Austen, J. 63
Author 29–30, 42, 49, 91, 93

Ballet 24
Balzac, H. de 41
Barnett, J. H. 61
Barrett, M. 102
Battersby, C. 109, 110, 115
Baumgarten, A. 12
Beatles 17
Beauty 27, 32, 69, 107
Becker, O. 29, 47
Beethoven, L. 16
Bell, C. 70–1
Bellah, R. 60
Benjamin, W. 62–3, 65, 66
Bennett, T. 15, 17, 57–8, 65, 89, 90, 107
Bensman, J. 76
Berger, J. 16, 63–4, 85, 98
Bernstein, R. 53
Besonderheit 86–8
Bird, E. 105–6
Bois, Y-A. 109, 110, 115
Bourdieu, P. 19–20, 22, 36–8, 47, 52, 83, 110
Bowness, A. 48
Brecht, B. 62
Brighton, A. 48, 49
British Journal of Aesthetics 27
Britten, B. 63
Burger, P. xii

Caudwell, C. 22
Caute, D. 29
Charpentier, C. 51
Chartres Cathedral 17

127

Clark, T. J. xiii, 15, 22, 67
Class 14, 19–20, 27, 28, 30, 31,
 32, 33, 36–7, 41, 52, 66, 113
Codes 22, 88–9, 90
Collingwood, R. G. 71
Courbet, G. 67
Coward, R. 102
Cowie, E. 102
Craig, S. 49
Crane, D. 106–7
Critical theory 52, 53–8
Criticism 11, 15, 16, 17, 18, 21,
 23, 31, 33, 66, 69, 83, 107
Cultural capital 36, 52
Cultural studies xiii–xiv, 22, 91,
 99, 113–14

Daley, J. 52
David, J. L. 51, 63, 64
Davies, T. 13–14, 15
Della Volpe, G. 84
Derrida, J. xii
Dickens, C. 51, 52
Dickie, G. 79
Dilthey, W. 53
DiMaggio, P. xii, 110–11
Discourse theory 90–5, 108
Disinterestedness 19–20, 29, 73–4,
 105
Douglas, M. 37–8
Drama 13, 69
Duchamp, M. 73
Dufrenne, M. 74
Duncan, C. 48

Eagleton, T. xii, xiii, 15, 25, 32–3,
 46, 64, 66, 89, 90, 102
Ehrmann, J. 62
Elliott, R. K. 71
Engels, F. 22, 41
Enlightenment 53
Ethnic arts 49, 51
'Excellence' 50, 52, 107

Federation of Worker Writers 49
Felski, R. xii

Feminism xi, 51, 106, 111
Fichte, J. G. 40
Flaubert, G. 35
Foucault, M. 91–5, 98
Fortin, N. 111
Fox, R. 22
Frankfurt School 22, 54
Freud, S. 101, 102
Fuller, P. 12, 15–16, 23, 25, 66,
 85–6, 95, 98–101, 103, 106–7

Gadamer, H.-G. 29, 53, 56, 58, 69,
 81
Garnham, N. 36
Gender 27, 33, 51, 52, 98, 101–3
Giddens, A. 56, 58–9
Glasgow School of Artists 106
Goldmann, L. 29–30
Gombrich, E. H. 14, 28, 72, 80–1,
 107
Goodman, N. 68–9, 71, 81–2, 84
Gowing, L. 16
Goya, F. 63, 64
Gray, C. 62
'Great tradition', 'great' art 11, 16,
 17, 35, 42, 52, 65
Greer, G. 51

Habermas, J. 53–8, 59
Hadjinicolaou, N. 15, 16, 24, 31–
 2, 35, 46, 62, 63, 64
Hall, S. 85, 88, 94
Haskell, F. 18–19, 20
Hauser, A. 13, 22, 28
Hawthorn, J. 47
Heath, S. 102
Hegel, G. W. F. 40; Hegelian 43
Held, D. 56
Hermeneutics 27, 29, 33, 46, 52,
 53, 56, 57, 69, 81
Hess, T. B. 51
Hesse, Mary 57–8
Hincks, T. 102
Hockney, D. 48
Hoggart, R. 51
Holbrook, D. 51

Hospers, J. 12, 27, 68, 69, 71
Howe, I. 63
Hungerland, I. C. 71
Hunt, L. 109–10, 113, 114
Husserl, E. 75; Husserlian 77

Ideal-speech situation 56
Ingarden, R. 74, 76
Institutional theory of art 73, 77–9, 82

James, W. 75
Jauss, H. R. 33–6

Kafka, F. 63
Kant, I. 12, 19, 73, 74, 76; Kantian 29; Kantian aesthetics 36, 76
Kaplan, C. 102
Keat, R. 55–7, 67
Khan, N. 49
Királyfalvi, B. 87
Kristeva, J. 65

Labriola, A. 98
Lacan, J. 65, 99, 101–4
Laclau, E. 91–2, 94
Langer, S. 71
Leavis, F. R. 15
Lenin, V. I. 62
Levine, L. xii, 110
Lichtheim, G. 24, 42, 86
Lilienfeld, R. 76
Lipshitz, S. 102
Literary mode of production 90
Literature 13–14, 15, 42, 84, 89
Longinus 13
Lovell, T. 25, 41, 42, 62
Lukács, G. 24, 38–42, 43, 82, 86–9, 91; Lukácsian sociology of art 25

MacCabe, C. 65, 102
McDonnell, K. 103
McGuigan, J. 49
Madame Bovary 34
Marcuse, H. 38, 42–4, 54
Marx, K. 22, 23, 38, 39; Marxism
43, 46, 52, 83, 95, 97, 98; Marxist aesthetics 11, 15, 25, 43, 65, 82, 83, 89; Western Marxism 96
Marxist-Feminist Literature Collective 64
Matisse, H. 18
Mercer, C. 94
Metz, C. 102
Middlemarch 16
Modernism 39, 65
Morawski, S. 71, 72, 74, 82, 83
Morris, L. 49
Mort, F. 102
Mozart, W. A. 18
Mulhern, F. 15
Mulkay, M. 53
Multiple realities 75, 81
Museum of Modern Art 48
Music xi, 13, 23, 66, 112

Natanson, M. 74
Natkin, Robert 23
Nelson, C. xiv
Nolde, Emil xiv, 24

Objectivity, truth 17, 48, 50–60, 62
Orientalism 111
Osborne, H. 12, 27, 68, 71

Parker, R. xii, 23, 51, 111
Parsons, T. 60–1
Pearson, N. 49
Phenomenology of art *see* art
Philosophical anthropology 25, 90–1, 95–9, 101
Photographs 37
Plato 13
Pleasure, gratification 24, 25, 31, 33, 74, 90, 95, 100, 106, 107, 108
Podro, M. 12, 73
Poetry 84
'Political Correctness' xii–xiii
Political value 17, 21, 26, 46, 47, 48–67

Pollock, G. 16, 23, 51, 93–4
Postcolonial criticism xi, xii, 111–12
Post-Impressionism 18
Postmodernism 114
Poststructuralism xi, 113, 114
Primitivism 111
Psychoanalysis 25, 91, 98, 99–104, 108; Kleinian psychoanalysis 99–101, 103; Lacanian psychoanalysis 101–4

Racine, J. 30
Radford, J. 102
Raphael, M. 83–4, 86
Realism 25, 39, 41–2, 87
Reception, reception aesthetics 32, 33–6, 38, 51, 112
Reductionism 24, 25, 30, 31–8, 83, 86, 93, 105
Reid, Norman 48
Representation 22, 64, 65, 88
Richardson, S. 64
Robins, K. 103
Royal College of Art 48
Rühle, J. 62
Russian Formalists 65, 89

Scharf, A. 62
Schiller, F. 12, 40, 43
Schutz, A. 75–6, 81; Schutzian 77
Scrutiny 15
Scruton, R. 68, 71, 72, 80
Semiotics 33, 89
Sexual politics 63
Sexuality 91, 92, 98
Shaw, Sir Roy 50
Social history of art *see* art
Sociology of religion 60; sociology of science 53, 60; sociology of taste 18–19, 36–8

Solzhenitsyn, A. 63
Specificity *see* art
Spinoza, B. 58
Sutcliffe, T. 49

Tagg, J. 83, 86
Taine, H. 22
Tate Gallery 48
Taylor, R. L. 20
Timpanaro, S. 95–8, 101
Todd, Jennifer 65–6
Tolson, A. 102
Totality 39–42, 82
Tuchman, G. 111

Universals, human constants, transhistorical features 16, 35, 43–4, 81, 87, 89, 90, 98, 99–101, 103–4, 107

Value, value-freedom 18, 26, 29, 32–3, 52–9, 106
Van Gogh, V. 93
Venus de Milo 99–100
Vermeer, J. 16

Wallach, A. 48
Watts, J. 49
Weber, M. 22, 52, 53, 58
Weber, W. 13
Weedon, C. 102
Williams, R. xiii, 13, 22, 24, 25, 36, 83, 85, 86–9, 90, 95, 97–8
Wilson, E. 102–3
Wittgenstein, L. 80
Wolff, J. 16, 21, 26, 30, 33, 88
Wollheim, R. 12, 14, 28, 30, 69–70, 71, 72, 77–9, 80–1
Women in art 23, 51

Yeats, W. B. 33

Ann Arbor Paperbacks

Waddell, *The Desert Fathers*
Erasmus, *The Praise of Folly*
Donne, *Devotions*
Malthus, *Population: The First Essay*
Berdyaev, *The Origin of Russian Communism*
Einhard, *The Life of Charlemagne*
Edwards, *The Nature of True Virtue*
Gilson, *Héloïse and Abélard*
Aristotle, *Metaphysics*
Kant, *Education*
Boulding, *The Image*
Duckett, *The Gateway to the Middle Ages* (3 vols.): *Italy; France and Britain; Monasticism*
Bowditch and Ramsland, *Voices of the Industrial Revolution*
Luxemburg, *The Russian Revolution* and *Leninism or Marxism?*
Rexroth, *Poems from the Greek Anthology*
Hook, *From Hegel to Marx*
Zoshchenko, *Scenes from the Bathhouse*
Thrupp, *The Merchant Class of Medieval London*
Procopius, *Secret History*
Fine, *Laissez Faire and the General-Welfare State*
Adcock, *Roman Political Ideas and Practice*
Swanson, *The Birth of the Gods*
Xenophon, *The March Up Country*
Trotsky, *The New Course*
Buchanan and Tullock, *The Calculus of Consent*
Hobson, *Imperialism*
Pobedonostsev, *Reflections of a Russian Statesman*
Kinietz, *The Indians of the Western Great Lakes 1615–1760*
Bromage, *Writing for Business*
Lurie, *Mountain Wolf Woman, Sister of Crashing Thunder*
Leonard, *Baroque Times in Old Mexico*
Bukharin and Preobrazhensky, *The ABC of Communism*
Meier, *Negro Thought in America, 1880–1915*
Burke, *The Philosophy of Edmund Burke*
Michelet, *Joan of Arc*
Conze, *Buddhist Thought in India*
Arberry, *Aspects of Islamic Civilization*
Chesnutt, *The Wife of His Youth and Other Stories*

Gross, *Sound and Form in Modern Poetry*
Zola, *The Masterpiece*
Chesnutt, *The Marrow of Tradition*
Aristophanes, *Four Comedies*
Aristophanes, *Three Comedies*
Chesnutt, *The Conjure Woman*
Duckett, *Carolingian Portraits*
Rapoport and Chammah, *Prisoner's Dilemma*
Aristotle, *Poetics*
Boulding, *Beyond Economics*
Peattie, *The View from the Barrio*
Duckett, *Death and Life in the Tenth Century*
Langford, *Galileo, Science and the Church*
McNaughton, *The Taoist Vision*
Anderson, *Matthew Arnold and the Classical Tradition*
Milio, *9226 Kercheval*
Weisheipl, *The Development of Physical Theory in the Middle Ages*
Breton, *Manifestoes of Surrealism*
Gershman, *The Surrealist Revolution in France*
Burt, *Mammals of the Great Lakes Region*
Lester, *Theravada Buddhism in Southeast Asia*
Scholz, *Carolingian Chronicles*
Marković, *From Affluence to Praxis*
Wik, *Henry Ford and Grass-roots America*
Sahlins and Service, *Evolution and Culture*
Wickham, *Early Medieval Italy*
Waddell, *The Wandering Scholars*
Rosenberg, *Bolshevik Visions* (2 parts in 2 vols.)
Mannoni, *Prospero and Caliban*
Aron, *Democracy and Totalitarianism*
Shy, *A People Numerous and Armed*
Taylor, *Roman Voting Assemblies*
Goodfield, *An Imagined World*
Hesiod, *The Works and Days; Theogony; The Shield of Herakles*
Raverat, *Period Piece*
Lamming, *In the Castle of My Skin*
Fisher, *The Conjure-Man Dies*
Strayer, *The Albigensian Crusades*
Lamming, *The Pleasures of Exile*
Lamming, *Natives of My Person*
Glaspell, *Lifted Masks and Other Works*
Wolff, *Aesthetics and the Sociology of Art*
Grand, *The Heavenly Twins*
Cornford, *The Origin of Attic Comedy*